Designs for Living

Designs for Living

Symbolic Communication in African Art

by Monni Adams

The Carpenter Center for the Visual Arts in cooperation with the
Peabody Museum of Archaeology and Ethnology Harvard University
Cambridge MA 02138, USA

Copyright————1982 by Monni Adams
Publisher————The Carpenter Center for
the Visual Arts
Harvard University
Cambridge, MA 02138
Distributor————Harvard University Press
Designer————Tsuneo Taniuchi
Map drawing————Tsuneo Taniuchi
Photographer————Margaret Landsberg
except as otherwise noted
Cover photographer—Hillel Burger
Printer————Arlington Lithograph Co. Inc.,
Arlington, MA 02174

Front cover————Kuba mask, Zaire
Peabody Museum of
Archaeology and Ethnology
Harvard University
Back cover————Konso pair of figures,
private collection

Library of Congress Catalog
card number: 82-72588
ISBN 0-674-19969-3
Main entry under author:
Monni Adams

Acknowledgments

My heartfelt thanks to all the collectors of the Boston area who generously cooperated in this exhibit and to the many friends of African art, both here and in New York, who contributed the financial support that made this exhibit and catalogue possible.

In response to both grass-roots interest from members of the Boston community and the desire of the Director of the Peabody Museum of Archaeology and Ethnology at Harvard University, C. Clifford Lamberg-Karlovsky, to stimulate greater interest in African art and culture, the initial plan was to hold an African art exhibit at the Peabody Museum. The project nearly came to an end with the prospect of an extensive renovation program which would close the public galleries at the Peabody Museum. Robert Gardner, the Director of the Carpenter Center, came forward at that time and generously offered to add the project to his exhibit schedule and include it in his budget. This location has not only made these private collections accessible to the public, but it has also encouraged us to bring out the richness of visual design and symbolic meaning of African art. I am grateful for the necessary services, so kindly performed, by the staffs of both institutions. I came to admire especially the professional skills and generous cooperation of Roger Brandenberg-Horn, Designer for the Exhibition Gallery at Carpenter Center.

My special thanks to Dr. Susan Vogel of the Metropolitan Museum of Art in New York, for her valuable judgment, and to colleagues, Dr. Jean Borgatti and Dr. Jane Martin, who donated their time and means of transport, and shared their knowledge of African art and society on our visits to private collections in the Boston area. This text has benefited from insightful refinements by a student of mine, a Harvard senior, Cecily Miller.

Monni Adams
Peabody Museum of Archaeology and Ethnology
Guest Curator, Carpenter Center for the Visual Arts
Harvard University

Lenders to the Exhibit

Mary Ellen Alonso
Bardar Collection
Prof. Julian and Doreen Beinart
Daniel Bell
Peggy and Daniel Blitz
Mr. and Mrs. Nathaniel C. Burwash
Prof. John and Dr. Virginia Demos
Dibby Falconer
Stanley H. and Theodora L. Feldberg
Amb. C. Clyde Ferguson, Jr.
Kate and Newell Flather
Susan and John Garrett
Barbara and Alan Goldberg
Dr. Hans Guggenheim
Dr. and Mrs. L. Lee Hasenbush
Nadine and Norman Hurst
Karob Collection
Herbert C. and Rose B. Kelman
Prof. Martin and Dr. Marion Kilson
Richard Lizdenis, Osterville
Prof. Boris and Adele Magasanik
Lorna Marshall
Prof. Daniel and Dr. Barbara McGaman
Genevieve McMillan
Prof. and Mrs. Willo von Moltke
Drs. Carolyn and Eli Newberger
Peabody Museum of Archaeology and Ethnology
Prof. and Mrs. Ithiel deSola Pool
Suzanne and Norman Priebatsch
Boris Senior
Mr. and Mrs. William E. Teel
George Wald

In addition, there are 8 collectors who wish to remain anonymous.

Contents

Foreword

The traditional art of Africa is by now so widely acknowledged as an aesthetic triumph that its examples have begun to stand for a kind of raw and essential beauty. Galleries, fashionable houses, even fashion advertisements are routinely adorned with masks and figures that convince us we are in the midst of something unambiguously creative. Less obvious, owing to the remoteness of the cultures which produced these objects, is the meaning which guided their making and attached to their use.

In this exhibit an effort is made to show how African art was seen, to some extent "read," by those whose lives it ordered not simply graced.

It is the business of the Carpenter Center to explore the relation between people and the worlds they fashion. We are delighted to have been asked to join with our anthropological comrades in presenting the fruits of a collaborative labor. I wish to thank especially Monni Adams who, with the informed enthusiasm of Genevieve McMillan and the flawless taste of Roger Brandenberg-Horn, has been the vital force throughout this undertaking.

Robert Gardner
Director,
Carpenter Center for the Visual Arts

Introduction

Artists, connoisseurs, and collectors have appreciated sculpture from black Africa since the early 20th century, but only in recent decades has its context been studied systematically so that we have any insight into the meaning. This exhibit of wood sculpture and surface design intends to reflect these two important aspects of late 19th and 20th century African art: the interesting, even captivating visual experience it affords and the context of action and symbolism that enriches the form.

Most of the visual art in black Africa, as in this exhibit, comes from settled agricultural peoples in the western and central parts of the continent. These objects are only part of a panoply of artistic means—dance, music, poetry, costume—used to fulfill certain purposes and to address problems faced by these sedentary village communities. A number of purposes are similar to those in our traditions: to convey messages about social values, to resolve social tensions and enliven community life, to enhance the status and prestige of leaders and other privileged individuals, and to give people sensory pleasure.

Some scholars feel that artistic efforts in general are more integral to African village life than to contemporary industrial society. This feeling I believe is due to a fundamental difference in the sphere within which some African art is used purposively. Non-industrialized African societies, like similar societies elsewhere, use artistic efforts to address problems in the sphere of *production*—as part of their efforts to produce more crops, more children, or a state of health, protection, or prosperity. Their creative efforts affect people who are concerned about problems of production. Industrial communities, including many in Africa today, try to fulfill those aims through scientific manipulation of matter, such as through the creation of machinery, and reserve artistic efforts for encouraging the sphere of *consumption,* that is, artistic means are used to stimulate people to consume. The ultimate symbol of this emphasis is the art for art's sake credo. The interesting point is not that African village art is functional and

industrial society's art is "useless" but that both kinds of societies use artistic efforts for a wide range of purposes. Some of these purposes overlap; however, others pertain to the distinctly different domains of production and consumption.

The explicit framework for most African art is religious. Except for ornamentation of the body, the ordinary life style is rather unadorned; objects are scarce. Specially made, enhanced objects we call art are created to address invisible beings, that is, spirits of various kinds and divinities, thought to have special powers to bring about prosperity, protection, and fulfillment of other desires. Affecting spiritual forces is the reported purpose for wearing jewelry by ordinary persons and for elaborate royal regalia.

African sculptors make much use of the human image, but they do not depict the body as it is in nature. They represent in smaller than natural size, human-like forms which are intended to provide a familiar place, a "house," for a spirit or deity to occupy when called upon to hear appeals from the people.

These invisible beings or forces are believed to share certain human qualities of a psycho-sensory nature: feelings, thoughts, and willingness to respond to human appeal, especially when cast in artistic form. Even harmful spirits, in order to be dealt with, are to be attracted by artistic means. Therefore Africans accompany their interaction with spirits with various artistic means: music, dancing, verbal arts, fine foods, ritual patterns, and visual elaboration? The combination of all these appear in full force at ritual festivals which involve most or all the community. These actions contribute to the people's sense of control over future developments.

The nature of spirit beliefs strongly affects the general character of African sculpture in another way. As anyone who has investigated spirit beliefs well knows, the nature of these spirits is not precisely defined. On the whole they are enigmatic and their followers expend great effort to find out what has offended them and caused misfortune, or what will induce them to produce favorable results for the believer. A third significant belief is that the human petitioner can influence the

spirit's attitudes and behavior. Therefore we find that the carver, in creating a "house" for the spirit, gives close attention to the form desired by the client (or his representative, the diviner), whose interests determine the general type or expression of the figure. The importance of this relationship between the carver and the client is in assuring that the form given the spirit has the character suited to the petitioner's purpose. The end result is that the petitioner provides, in the form of the sculpture, a symbolic model for the spirit and how it is to interact with the petitioner. Altogether in African sculpture we see a composite manifestation of these three concepts in varying degrees: human-like features, enigmatic character, yet some definition in terms of the type of figure given by the petitioner's interests.

This exhibit offers approximately a hundred examples of African artistry. These sculptures, masks, textiles, and other objects are grouped according to three broad topics: art in relation to ideas about the cosmos, the community, and the individual. The section, "Art and the Community," forms the largest part of the exhibit. Scholars have given much attention to the arts involved in communal activities, and the social function of African art is now familiar to a wide public. Benefiting from this tradition of scholarship we present works of art under five headings: figures that serve as founders and protectors of the community, masks and figures that promote prosperity and well-being, offer designs for gender, or perform as task forces for the community, and materials that function in the money and costume systems. These headings suggest the range of purposes served by visual arts. Within each section, examples from different regional or ethnic groups make us aware of the diversity of styles created by local artists.

A great deal of African art does relate directly to community interests. Figures and masks are part of the artistic efforts involved in fostering the cohesion of the village. Earlier, when these practices developed, there was plentiful land and low capital requirements, so people could break away from a village and resettle; on the other hand, prior to the 1920s village life offered the advantage of protection from hostile attack. Considerable effort therefore was put into creating two kinds of

social pressure: one to keep the village cooperative and united, the other to develop aggressive abilities for possible defensive or offensive purposes. In settled communities, where the same people are involved in many kinds of face-to-face interaction, the issues of maintaining social order and ensuring fulfillment of tasks becomes more acute than among a herding or nomadic people who have little investment in a locality and can easily separate and move on. In my view the essentially communicative character of visual art, which can be shown in a sustained and repeated manner to all alike, enhanced by its power to affect people, helps account for its rich development for social control and other communal tasks among settled peoples.

Artistic efforts also come to the fore within the village at certain sensitive points of group interactions: particularly relations between founders and later settlers, between elders and youth, between men and women. In day to day life these relations are handled by various methods, such as arbitration, disputation, and force, but at certain times and occasions they are dealt with symbolically at religious rites and festivals. These occasions provide a public arena for the use and display of the figures and masks that comprise the corpus of African art. We see these art objects as a way of communicating in heightened symbolic form the identity and tensions of the interacting groups.

The aesthetic aspect of these symbolic forms however is not addressed explicitly to the members of these groups among the spectators, but to the invisible world of the spirits or gods. This indirection of address is a typical way of handling problematic social interactions—perhaps because of the enforced intimacy of village life. It complicates the investigation of reactions to these objects as art forms. Village people are nonplussed by questions about whether *they* like the forms; they see the display as directed toward the other world. Although they will act to give money and gifts to excellent performers and respect holders of sculpture, judgment of their affective response to visual forms is often tacit, not a ready part of their conscious expression. However, my assumption here is that the people are responding to the artistic elaboration at these festivals as much as they are eating the food, which is

similarly produced for and offered to the spirits, but consumed by the spectators.

To miss this point about indirection as a cultural style has serious consequences for it leads some critics to say that the artistic aspects are of no interest to the Africans because the sculptures are not made to be appreciated for their sensuous qualities but for utilitarian or functional purposes. Once we realize that indirection is the style of expression appropriate to certain social situations, that organized ritual is seen by the people as a different kind of experience from rational debate, and look at the facts: that these people commission, pay for, and produce, along with other artistic activities, objects which fulfill our definition of visual-art qualities, then it seems more reasonable to assume that they *intend* to create the conditions of sensuous perception, that indeed it is precisely *the aesthetic aspect* that is to affect the spirits who in turn will solve their problems. The source of the perceived technical efficacy and actual social impact of these objects is their formal arrangement.

The interest in affecting the spirits by artistic means does not mean that all visual forms are to be beautiful by local standards. For various reasons, as we will see in the exhibit, some are meant to be frightening, ugly, coarse, aggressive. However, that negative effect is ordered in artistic ways, just as we consider a play that ends tragically a form of art because of its interesting structure and strong affect. Neither the beautiful nor the frightening works of African sculpture are meant to be realistic depictions of persons or spirits; they are rather portraits of qualities, that is, symbols, which are invoked to promote the purposes of the owners.

In the mask corpus, we find another major subject matter that illustrates and reinforces our view of the symbolic nature of the carvings: parts of different animals, often mixed with human features, are put together not to depict an actual animal but reportedly to bring to mind such qualities as speed, beauty of movement, industry, wisdom, ugliness, cleverness, ferocity, and power. These qualities are to provide models for human behavior. For example, features of the leopard, elephant, crocodile, large birds, such as the hornbill and eagle, are used to

identify leaders. These powerful creatures of the forest, streams, and sky serve very widely in black Africa as symbolic models for human leadership.

As important as art works are in social life, in this exhibit we want also to bring out two other topics less frequently mentioned in relation to African art: the cosmos and the individual. Of course all three topics overlap but separating them momentarily can expand our sense of the range of meaning in African art works. Specific examples of art focused on individual interest are abundant in reports on African societies. We single out and bring together a few to counteract the overwhelming and confining emphasis on the communal aspects of African art. The struggle for individual achievement and personal distinction as well as the conflict of self-interest versus group welfare are lively tension points in African society.

Until recently African visual art and the cosmos was a little studied topic, and we focus on one example: a brief excerpt from the cosmology of the Dogon people of Mali, as known from an old Dogon philosopher named Ogotemmêli, and its relationships to parallel patterns in ritual and visual art. By cosmology I mean the conceptual categories, the unquestioned assumptions about order in the world and in human life. These are not usually summarized in stated beliefs but have to be constructed from myth, ritual procedures, institutional practices, and art forms. To distill a cosmology requires someone deeply knowledgeable about the society and its culture. Meditations on this larger framework belong to the secrets of the elders. Even when, as in the case of the Dogon philosopher, this secret knowledge is revealed, it is cast in the form of metaphoric and poetic narrative which in turn must be interpreted in the light of many aspects of the local culture. We want to illustrate in man-made things and ritual activities the importance of design as a model for the behavior of men and their gods, and as a statement of their interaction.

We do not understand fully for any culture the process of artistic creation, but it seems reasonable to assume that the artist works from conceptual categories shared with his society. Visual symbols objectify

conceptual categories. Therefore the more we learn about the corpus of symbols, the more likely we are to gain insight into the subject matter and style of the artist's work. We begin this exhibit by illustrating how a few facets of Ogotemmêli's ideas about the order of the world are exemplified in design and structured objects.

Caption Text

In the caption text, the first line provides a brief description of the object and its size in inches; all objects are of wood unless otherwise noted. The second line gives the attribution of ethnic group and state. This is followed by the name of the collector and whatever other information the collector provided, usually the dealer, locality, and year of acquisition. References following the captions indicate sources from which information was drawn.

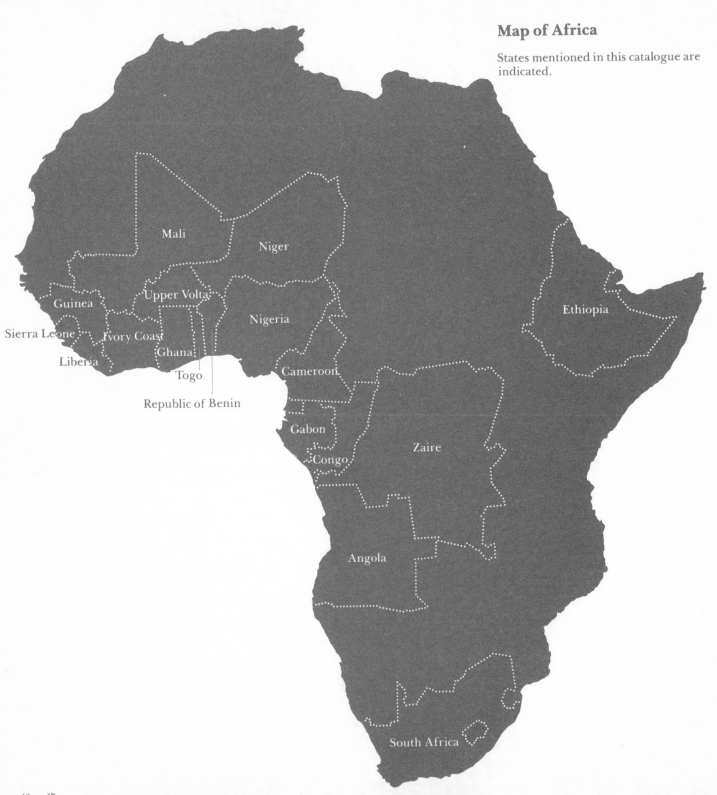

Map of Africa

States mentioned in this catalogue are indicated.

Mali

Niger

Guinea

Upper Volta

Sierra Leone

Ivory Coast

Nigeria

Ethiopia

Liberia

Ghana

Togo

Cameroon

Republic of Benin

Gabon

Congo

Zaire

Angola

South Africa

Art and the Cosmos

The Divine Geometry

The Dogon people live in the near-desert region of Mali below the Sahara, cultivate fields of grain and gardens of onions, and weave cotton cloth. From their scattered village settlements, they congregate to sell their small surpluses in large weekly markets. Villages link together not by political leadership but by mutual obligations to organize religious festivals, which include music making, dancing, and feasting as well as prayer and offerings.

An old Dogon philosopher Ogotemmêli revealed to an anthropologist he knew for many years secret beliefs about the creation of the world and divine geometry. His account of the founder of the Dogon people combines a keen sensitivity to forms with lively actions.

The first ancestor was a being with an undulating green body who constructed the model of our world system in the shape of an inverted market basket. This large basket was made up of two primary geometric shapes, the circle at the base, representing the sun, and the square at the top, the night sky. On the four sides of the basket, he constructed stairways of puddled clay and soil which held the word-symbols for all the creatures of the earth. Onto this stable, truncated pyramid form, he added a spindle of thread that unwound in serpentine coils like the movement of water. This spiral thread, which he likened to breath spiralling out of the mouth, stood for knowledge of the Spoken Word, which initiated the process of human civilization.

He shot the thread into the sky and received the hammer and anvil, tools of the smith, needed to make hoes to work the ground, the basis of the Dogon way of life. He copied the form of the miraculous basket to use as a future granary. He then stole a piece of the sun, and flung the basket along a rainbow to descend to the earth. The shock of his impact broke his undulating limbs at the level of the elbows and knees and created the joints which enabled him—and his human descendants thereafter—to use tools at the forge, the loom, and in the fields.

Griaule, M. *Conversations with Ogotemmêli* (trans. from the French *Dieu d'Eau,* 1948), 1965.

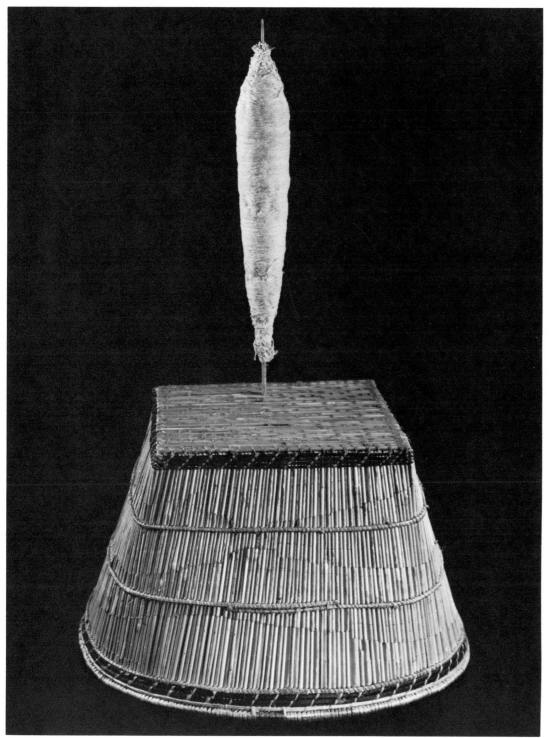

1-2

The Spiral and the Checkerboard

The Dogon link supernatural creation to spiral or zigzag movements. They see signs of the creative process in the unfolding of a leaf or the coiled baby in the womb. In the annual festival that commemorates the original creation of grain and the creative energies of the seed to be planted, the whole community moves in a spiral path around the ritual precinct. Water, viewed as the essence of creative force, is shown in the form of zigzag, serpentine lines.

In contrast the Dogon indicate the products and actions of human beings by horizontal and vertical lines, which meet to form grid systems and checkerboard patterns. For the Dogon, checkerboards are preeminently the symbol of "things of this world." We see this pattern in the layout of their fields, which are divided into small ridged squares, and in the art forms: architecture, light and dark woven cloths, and even in the structural tendencies of sculptural style.

The Dogon liken their checkerboard-patterned cloths to the shadow and sunlight on squared fields and village houses. The rectangular, recessed areas on the façade of the *ginna,* the large family house, reiterate this significant patterning. Religious rites aim to combine human and divine efforts and the important sanctuaries are painted at festive periods with both design categories: zigzag water lines and checkerboard patterns. All sculpture involves a tension between horizontal and vertical forces, but Dogon sculpture is distinctive for its emphatic use of clearly defined horizontal and vertical elements. These visual grids express the Dogon design for human order.

DeMott, B. The Spiral and the Checkerboard, in D. Fraser (ed.), *African Art as Philosophy*, pp. 17–19, 1974.

1—**Women's market basket** (fiber) 17″
Hans Guggenheim–Acquired in Mali

2—**Spindle of cotton yarn** 20″
Peabody Museum, Harvard University
B5075

Arranged in the shape of the mythic world
system.
Photo credit: Hillel Burger
Sketch of the world system according to
Dogon myth (Griaule 1965:33).

Spiral movement out of the cosmic womb
(Adapted from M. Griaule. See D. Fraser
(ed.) *African Art as Philosophy*, 1974, Fig. 11.)

3—**Checkerboard patterned cloth**
(cotton) 80″ x 55″
Hans Guggenheim–Collected in Mali

Strips of narrow cloth are sewn together in
such a way that the bands of decoration
appear as irregular accents, thus enliven-
ing the repetitive checkerboard pattern
and making each cloth different, the result
of the individual weaver-designer's deci-
sions. Irregular variation is typical of Afri-
can surface design. This kind of cloth is
essential to cover the deceased during
funeral rites, the finished cloth and the
funeral showing the completion of the per-
son's pattern of life.

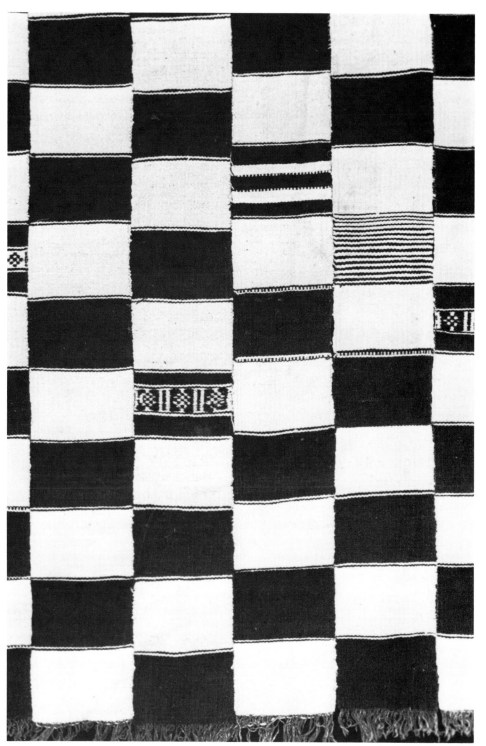

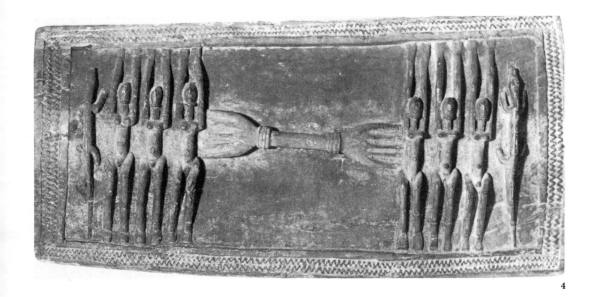

4

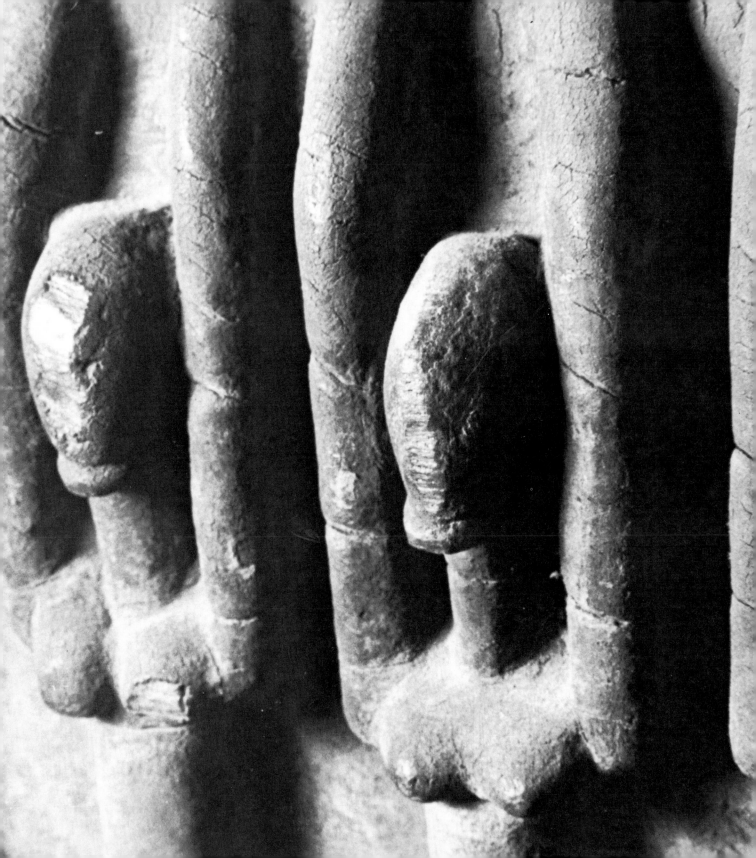

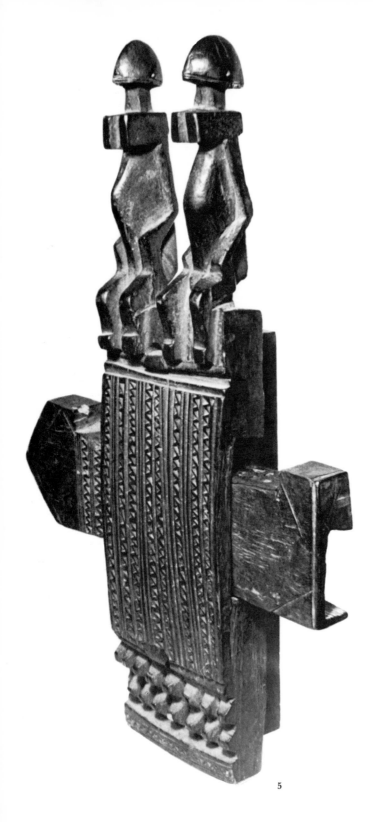

5

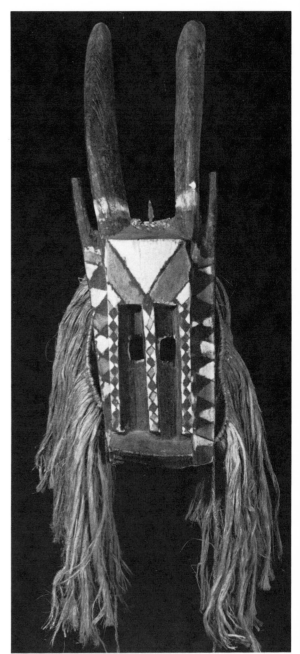

6

4——**Rectangular cover of a ritual container** 36″ x 16½″
Lorna Marshall–From C. Ratton, Paris, 1966

This cover was probably for an oblong box, usually carved with a horse's head and tail at the ends, to hold ritual implements or food stores at ceremonial feasts. The image of two hands forming the handle offers a visual pun. The preference for strong horizontals and verticals in Dogon sculptural style is apparent in the extended human figures and the contrasting line of the hands. Although the composition is symmetrical, small variations in angle of pose and position of the lizards prevent an effect of mechanical rigidity. Small freestanding human figure sculpture was used by the Dogon as guardians of goods; the figures on the lid may serve the same function.

5——**Doorlock in two parts** 11″
Karob collection–From Mohammed Kabba, 1971

A guardian pair of male and female figures watch over the doorlock. The lock is constructed of a vertical and horizontal bar, a type widely known in the Mediterranean world. The two rows of knobs at the base of the lock and the feet and shoulders on the human figures provide blunt horizontal accents to contrast with the decorative vertical lines.

Freyer, B. Lock/Door in D. Fraser (ed.), *African Art as Philosophy*, 1974.

6——**Polychrome face mask**
(with fiber ruff) 30″
Drs. Carolyn and Eli Newberger–
Obtained in Ouagadougou,
Upper Volta, 1968

A crowd of already initiated youths wear face masks–many with antelope horns, as in this example, or rabbit ears–in dances to celebrate the coming out or graduation of younger boys from the circumcision camp, and at other communal celebrations, such as commemoration of the death of persons important to the community. Although most of the wooden masks exhibit a simplified abstract face like this example, the Dogon recognize about 200

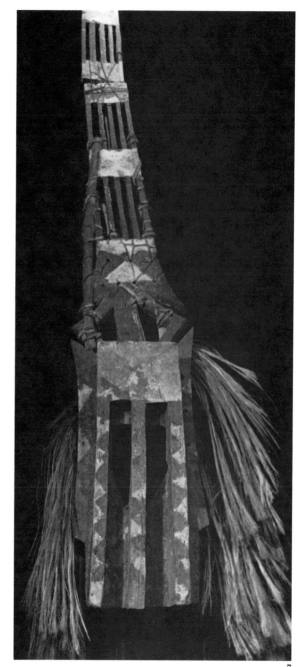

7

different personalities or animals, based on small cues, or facial details. Apart from a few abstract types, the masks can be grouped into predators, such as hunters and warriors, and non-predators, such as various antelope species. The facial structure of this mask type resembles the recessed façades of certain sanctuaries, as both feature strong vertical lines and both are painted in light and dark checkered and zigzag patterns.

DeMott, B. *Dogon Masks: A Structural Study of Form and Meaning,* 1982.

7—Polychrome face and plank mask
158″
Drs. Carolyn and Eli Newberger—
Obtained in Ouagadougou,
Upper Volta, 1969

At the end of a major dance ritual such as the commemorative funeral, one or more of the tall masks emerges to connect the community and the event with the rhythms of the cosmos. The long panel is called the "many storied house," symbolizing the group of houses that make up the community. In a circle formed by the spectators, the wearer of the mask slowly turns in the movement of the sun, to the east, dips the tip to the ground, then to the west, to signal the completion of the rite and the course of a human life. The plank form may derive from panels set up at graves found in nearby regions.

8—Fiber mask
(cotton and shell trim) 15½″
Peggy and Daniel Blitz—Obtained near Sanga, Mali, 1971

A fiber mask exhibits a rare use of the spiral form in a hand-made object. The mask is worn by a man to represent a "foreign" woman from the Peul, nomadic herders who migrate through Dogon territory. The Peul women, who are decoratively groomed, are seen as having dangerous powers because of their compelling beauty.

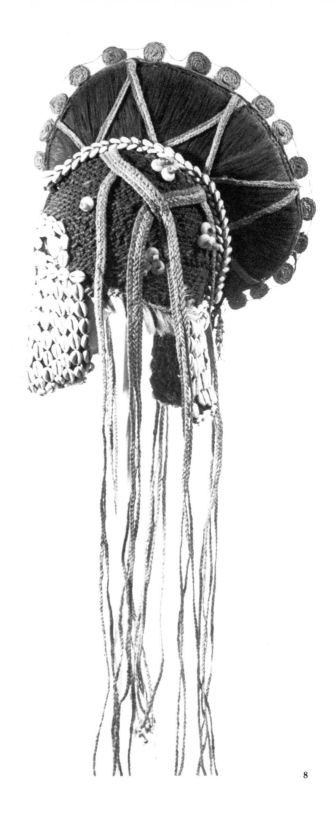

8

Art and the Community

Founders and Protectors of the Community

Founders of a community are remembered in important ways because they were the ones who first cleared the land and established favorable relationships with the spirits of the place in order to assure future crop success and good health for the subsequent inhabitants. Should this original "contract" fail, indicated by bad harvests or much illness, the people move to found another village. Protectors of the community may perform in a variety of modes: warrior's exploits, giving advice through divining talent, guarding the bones of powerful predecessors, punishing anti-social acts, or maintaining good relations with local spirits by just administration.

In these small communities, elders are respected. As the major store of knowledge lies in the minds of the older generation, they are seen to possess the secrets of survival and well-being. Their influence and interest in their descendants is thought to continue after death. Deceased elders, being yet older, are considered to possess even more knowledge and powers and thus obtain special veneration. The figures carved to commemorate these ancestors or more often the recently deceased do not depict any particular person but present the idea of the human progenitor, as an isolated figure outside of time and space, or as a pair, male and female, who were necessary to the founding and prosperity of the village.

Despite the continuing importance of deceased elders, it is important to note that many sculptured human figures are dedicated to spirits other than ancestors. Prominent in this section are guardian figures (tutelaries) who are protective in function. In general, sculptured figures which serve the community are larger than other local sculptures.

These images provide a familiar place for the spirits to return, a house or place to sit, in order to hear the appeals for blessing, for help in times of trouble, or for aid against enemies. By way of thanks and appeasement the community gathers from time to time, regularly or at times of crisis, to communicate with the spirit figures, make token offerings of festival food, and provide them with entertainment.

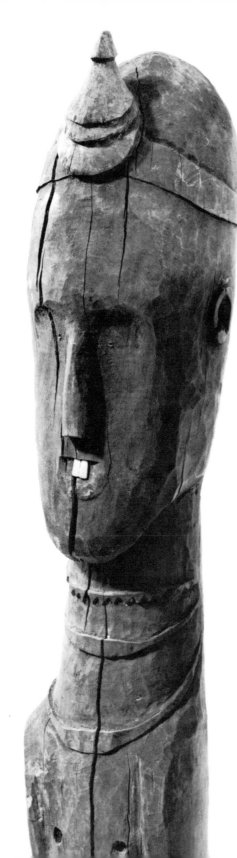
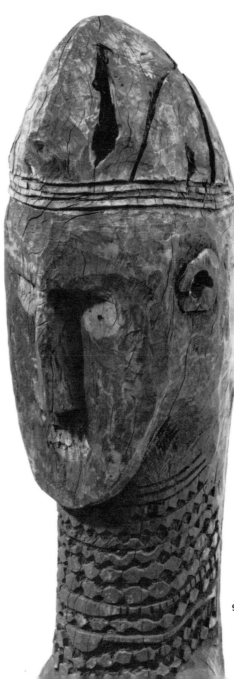

9

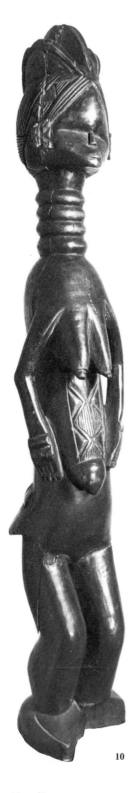

10

9——**Male and female figures** 4′3″ and 4′
Konso, southeast Ethiopia. Exceptionally
rare
Private collection—Collected from a Konso
village in 1967 *(Back Cover)*
Photo credit: Hillel Burger

Among the Konso, only outstanding
deceased warriors were honored by their
community with a stone-lined memorial
plaza set up near a crossroads. Encircled
by walls, the plaza consisted of large
wooden statues representing the spirit of
the warrior and his wife, and several of his
most famous victims. These stood behind
rows of tall spears and stone columns. The
location of the memorial at the crossroads,
which were viewed as dangerous places,
was intended to ensure that the warrior, as
he did in life, should protect the village
from attack of harmful spirits or advanc-
ing foe.

 Originally the color contrast in the faces
would have been even more startling with
white ostrich-shell eyes. The warrior's
bared teeth are made of hardy goat bone.
The ornament on the warrior's forehead is
a sign of great spiritual power, the neck-
laces and arm band jewelry a mark of high
rank. On both figures the compressed
pose and intense stare coupled with the
severe features convey a penetrating effect
of pent-up force, appropriate to the
threatening aspect of such spirits.

Cowen, C. The Monumental Architecture
and Sculpture of the Konso of Southern
Ethiopia. M.A. Thesis, University of Okla-
homa, 1974.

10——**Standing female figure** 31¼″
Sherbro, Sierra Leone
Private collection—Gift from Mary Adams,
1933

This type of figure was set up in a special
shelter in the center of the Sherbro village
by the Yassi society and was tended by a
priestess who consulted it in times of com-
munity need. In a trance, she would dance
with it and from its movements discern a
message in response to her inquiries.
 There are few figural sculptures from
Sierra Leone in this country and this one is
an exceptionally fine discovery. It was col-
lected by Fitzmaurice Manning, medical
officer of the British military who served

in Sierra Leone in 1894. His daughter gave
it to a Boston couple at their wedding 50
years ago, thus it is an authenticated work
of the late 19th century. The hand of the
same sculptor can be recognized in
another female figure, now in a Swiss
museum, collected by Dr. Walter Volz, who
travelled through the Sherbro region in
1906.

Zeller, R. (ed.). Reise durch das Hinterland
vom Liberia im Winter 1906/07 von Walter
Volz, *Jahresbericht, Geographische Gesellschaft
in Bern* 22, 1908–10.
Lamp, F. Letter May 7, 1982.
Adams, Mary. Letter May 10, 1982.

11——**Human figure** (fragment) 25″
Hemba, Zaire
Private collection—Obtained from
de Monbrison, Paris, 1960

A true ancestor figure that memorializes a
deceased leader of a family group. Posses-
sion of this figure demonstrates proper
descent, thus legitimizing leadership con-
trol over the use of land and access to the
spirit world. Not just any predecessor is
honored by becoming an ancestor, only
those whose families are able to sponsor a
series of public festivals which are believed
to please the ancestors so that the recently
deceased may be permitted to join them in
the spirit world. Following a recent style
analysis, this figure because of its hairstyle,
three projecting braided cones (Neyt's 7b),
and delicate linear facial features may be
attributed to the eastern fringe of the clas-
sic Niembo region among the southern
Hemba. The grey, clay film over the sur-
faces and certain deterioration of the
wood parts suggest the figure had been
buried.

Neyt, F. *La Grande Statuaire Hemba du Zaire.*
1977.

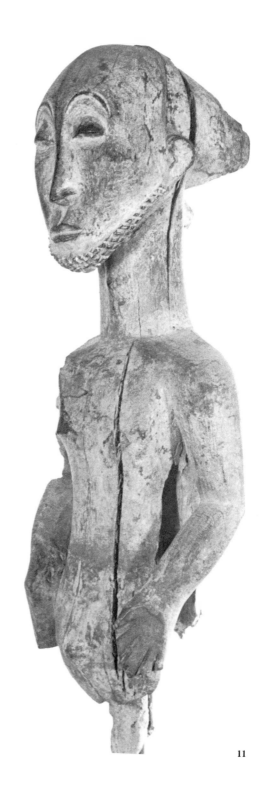

11

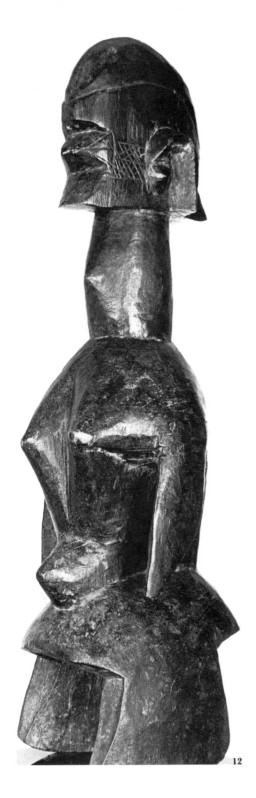

12 — **Female figure** 16¾″
Mumuye, northern Nigeria
Private collection—From Galerie Hélène Kamer, 1981 (Kamer collected it from the Kona subgroup.)

Guardian spirits or tutelaries and helper spirits are usually invoked from the world of nature, that is, rivers, mountains, trees or other features, rather than from the world of humans. However, despite an essential dissimilarity, the spirits are considered to hold sufficient attributes in common with humans to attend and respond to their appeals and to manifest themselves in figures with varying degrees of human form. Mumuye figures in the possession of important elders may be appealed to as oracles to tell who is guilty or who is lying at a trial—if there is difference among witnesses, each will swear on the statue while embracing it—or for their apotropaic value to ward off harm. Possibly the great style variation evident within the Mumuye corpus of statues originally reflected subgroups, but it is not possible at this time to assign precise locality or function to a figure on the basis of style.

Fry, P. Essai sur la statuaire Mumuye, *Objets et Mondes* 10, 1:3-28, 1970.
Rubin, A. Nigeria: Figures 91 and 92, in S. Vogel (ed.), *For Spirits and Kings,* Metropolitan Museum of Art, New York, 1982.
Rubin, A. Letter May 30, 1982.

12

13 — Seated male figure 12″
Fang, Gabon
Private collection – Obtained at end of
International Exposition of Arts and
Techniques of Spanish Guinea (now Rio
Muni), Seville, 1929

In the forest communities of Gabon, this
seated figure is placed as a watchful
guardian over a cylindrical bark box con-
taining fragments of the bones of out-
standing men or women of earlier times.
The expansion and contraction of the
shapes in the arms and legs increase the
feeling of tension in this guardian figure.
In its hands is a container, probably meant
to hold magical substances to ward off
harmful forces. This protective unit,
called *bieri,* is kept in the quarters of the
recognized head of a group (lineage) of
male relatives who trace their descent
from a common founder. Possession of the
bone relics is linked to the corporate unity
of the kin group and provides spiritual
access to the family achievers. When the
family expands, the bones are shared with
the separating segment.

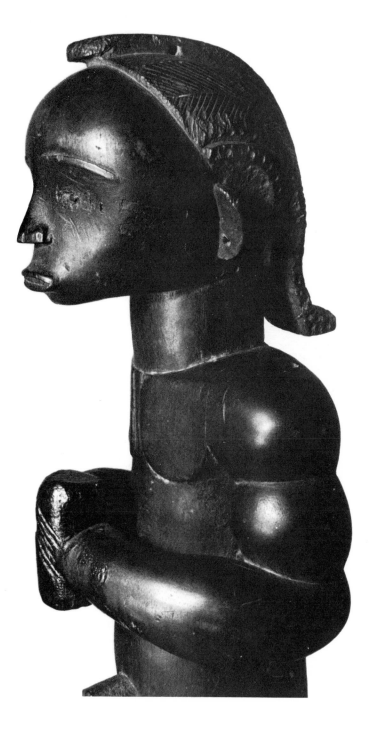

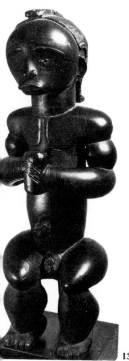

13

Balance and Opposition Obtain Vitality

Fang figural sculpture exhibits a consisten
bilateral symmetry. Fang informants
spoke of the need for balance (*bipwe*) of
limbs on the opposite sides of the figures
for the figure to obtain vitality (*enin*).
Another set of opposite qualities in the fig
ures is adult and child-like features. The
small size and short limbs suggest the
infant, while the grooming, expression,
posture control, and sexual development
show adult status. This mixture creates an
unusual impression on our public who
expect either one kind of image or the
other. The mixture is subtle so that we do
not easily shift from one to the other but
remain engaged by the puzzling combina-
tion. The ambiguity of form helps to sus-
tain lasting interest.

The concern for balanced oppositions
recurs as a consistent "motif" defining the
order of Fang social life. It is manifested i
their concepts of the forest and the village
in the physical structure of the village, anc
in the male and female character assigned
to the two kinds of village buildings.

In the mind of every Fang there is an
important affective contrast between the
forest and the village, which present con-
trasting arenas of experience and produc-
tion. The forest is cold and the prime
arena of male activity: hunting, warfare,
defense of frontiers. The village is seen as
hot, as the arena of women's work: the
cooking of food, and raising of children.
There is a conceptual opposition between
the two domains, the familiar and domes-
tic activity of the village with its associated
gardens and plantations, and the deep for
est with its useful trees, its game, its well-
stocked streams but its alien uncertainties
Yet between them there is a recognized
complementarity and interdependence.
The village and gardens are cut out of the
equatorial forest and surrounded by zone
which grow wilder by degree and nearly a
the forest has been cleared land at some
time in the past. Men circulating back and
forth between the forest and the village
balance their experience within these con-
trasting spatial regions, thereby maintain
ing a lasting and vital community.

A simple model of the domestic spaces i
shown in the accompanying diagram. The

village, formerly enclosed by palisades, is a symbol to the Fang of a self-contained enclave, a microcosm, very clearly defined against outside neighbors seen as hostile. Yet within its very structure the village expresses opposition. A settlement is not a village until there are two long rows of houses across the barren courtyard where, as the Fang say, they can shout insults across the court at each other. Thus the structure of the village was symbolic; it conveyed meanings of both opposition and of solidarity. This lively sense of village competition is echoed in the way the Fang structure the game board (*wari* or *kala*), making the holes in the shape of their house forms; they try to capture the pellets of the opposite side as occupants of "houses."

The two principal types of buildings within the village provide another balanced opposition. The houses (*nda-kisin*) in long rows belong to the women's world; while at the ends of the village the *aba*, the men's council houses, are the sphere of masculine activities. The *kisin* is the place of birth, cooking, and childcare; men sick or dying prefer to return to a bed in this female section. Thus it is linked with primary physical experiences. The men's council house is a place of talk. There the men practice their crafts and at night it is a center of story telling and entertainment by travelling troubadours who recount the wondrous tales of the past. It is an arena for the creative imagination. The two arenas of opposite character were essential to the "balance" of the Fang community.

Fernandez, J. Balance and Opposition in Fang Aesthetics, *The Journal of Aesthetics and Art Criticism* 25, 1:53-64, 1966.
Fernandez, J. *Fang Architectonics*. ISHI, Philadelphia, 1977.

Sketch of the Fang village and their game board. Drawing by Renate Fernandez. Courtesy of James Fernandez.

14— Metal-plated concave face 30½"
Kota (Obamba), Gabon
Karob collection—From J. Klejmann, New York, 1974 (from the lower Ivindo River)

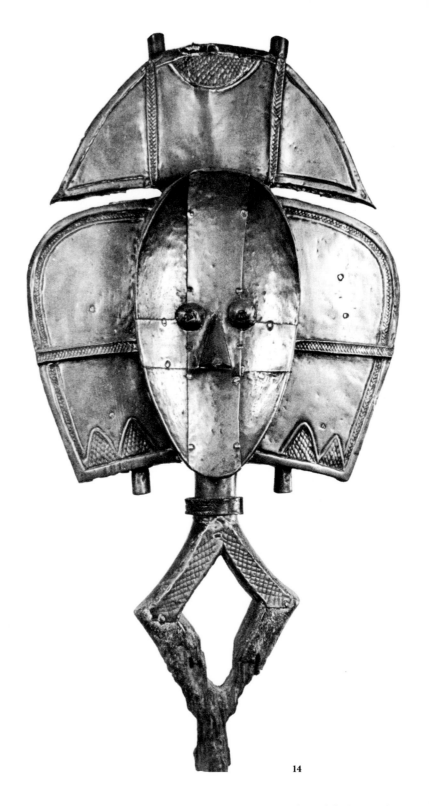

14

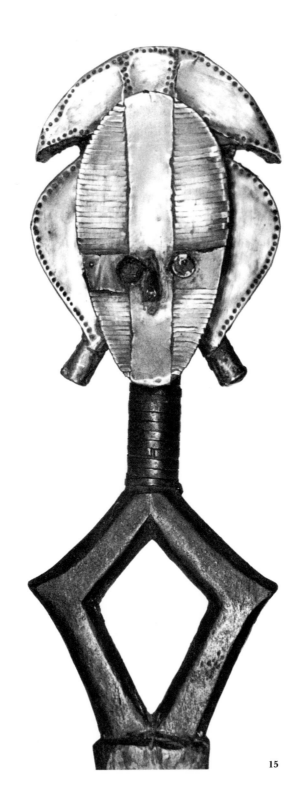

15

5—Small metal plated face 18½"
Central Kota (southern Shamaye-northern
Obamba), Gabon
Genevieve McMillan—Acquired from
Madeleine Rousseau, Paris, 1944

6—Metal-plated convex face 30"
Kota, southern style (Mindassa-
Mindumu), Gabon, Republic of Congo
Norman and Nadine Hurst—Acquired
from old family estate in New England,
1981

Several ethnic groups termed "Kota" in
Gabon use this kind of abstract figure to
serve the same purpose as the Fang statue:
as guardians for ancestral bone relics kept
wrapped in baskets or bark boxes. These
figures are unusual in African representa-
tions of the human head because of their
flat, two-dimensional character and the
plating with metal over a wooden base.
The head rests on a tiny column which
opens to lozenge shaped arms. These
would be set into the basket containing the
bundled bones, the bundle forming a pro-
tective enclosure (a womb) for the precious
relics.

The metal plate derives from expensive
brass pans purchased from European
traders. Its reflective surface was desired
as a means of warding off witchcraft at the
same time as its use indicated wealth. The
formal arrangement of flattened hairstyle
provides even greater display of the luxu-
rious metal. These pieces illustrate two of
the three major styles of the Kota brass-
covered reliquary. The attributions are
based on the study of styles by the Chaffins.

Siroto, L. The Face of Bwiti, *African Arts* 1,
3:22-28, 86-89, 1968.
Chaffin, A. & F. *L'Art Kota*, 1979.

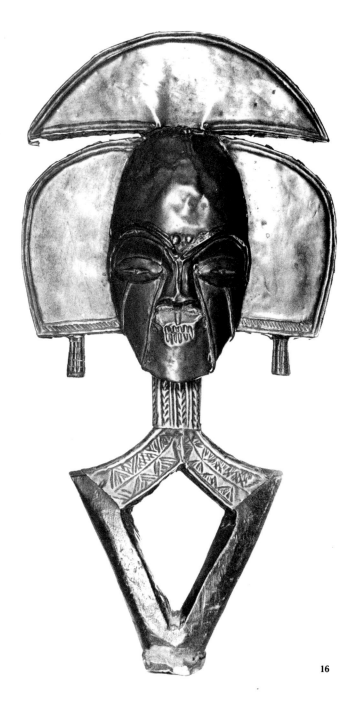

16

Prosperity and Well-Being

If an agricultural community is to survive, the people must obtain sufficient crops and reproduce its population. The soil in West and Central Africa generally is not fertile nor easy to work. Yet success could be achieved through dedicated cultivation and the orderly fields in the grasslands between the Sahara and the rain forest belt along the coast elicited the admiration of early travellers. Festivals at planting and harvest did a great deal to encourage working of the land under the harsh conditions of the sub-Saharan region. Especially in southern Mali these festivals included many theatrical events such as morality plays, puppet shows, and the appearance of masked dancers. These entertainments sought to please the unseen forces that would affect the crops, and by the promise of this achievement to revivify the community. At the same time, the grace, excitement, or wit of an artistic event ensured the attention and favorable response of its human audience. Thus reinforcement of community spirit increased social incentive for the individual farmer. Seen pragmatically, good crops would mean wives and children and a higher position in society and the prestige of sponsoring religious rites. Economic incentives were enhanced through aesthetic means.

It is typical of black Africa that masks appear at times of transition, such as the change of work season, thus at planting and harvest, and change in human status, such as initiation from child to responsible youth or at funerals, which mark the transition from bodily person to spirit form. Usually such masks combine features of more than one kind of creature, especially animals and human. We can understand this as a visual parallel to the temporary overlap or mixture of the two states. The overlap serves both to acknowledge the presence and power of anomaly and to reinforce the perception of normal proper categories through the strange effect of the juxtaposition. The widespread belief that special forces of fertility are active in the uncultivated woods or grasslands or forest—to be referred to here as the bush—results in the recurring use of specific motifs or subject matter in emulation of a

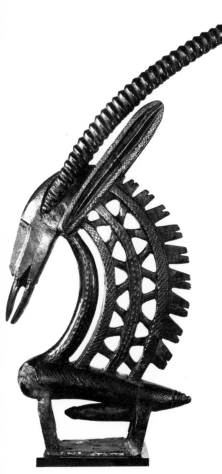

realm where plants and animals flourish without human effort. Wishing to capture this ever-renewing vitality of plants and the powers of wild or unusual animals, the villagers bring elements from the outside world of the bush into the village and manipulate them ritually in a manner we call symbolic. Fertility of the plant world is represented in ritual by means of fiber and leaf masks and costumes, and by masks made from wood cut from live trees, some of which are stained with plant dyes or earth pigments. Plants are rarely depicted in African sculpture but actual herbs, leaves, and roots, as well as special parts of wild animals such as feathers, claws, or teeth, are hung on costumes or brought into many rites. Imagery in animal or human-like form also serves as vehicles for transferring vitality from the outside world into village endeavors. In some areas, wood sculptures which are worn and danced with are the primary focus of community ceremonies.

17

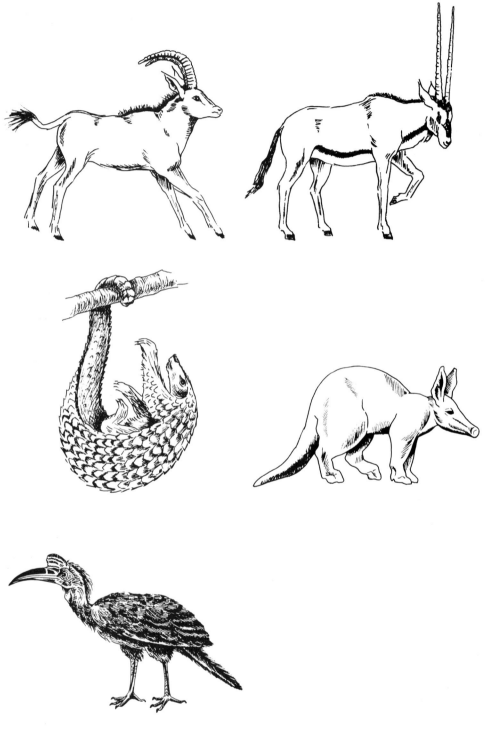

Crop Fertility

17—**Male antelope headdress** (*tyi wara*)
32"
Bamana (Bambara), eastern region, Mali
Private collection—From J. Klejmann, New
York, 1959

The most widely known work of African
art—the antelope headdress—is produced
by Bamana carvers as the dramatic feature
of a planting festival. The roan antelope
symbolized here is the largest animal of
the grasslands; the male's horns are curved
as in this example. The partner for this
headdress is a female antelope, whose
horns are shown as straight, which may
refer to another species, and in many
examples she carries a small antelope on
her back.

In earlier times two men, one wearing a
male antelope headdress, the other, a sim-
pler female version, danced on the com-
munal field, while other young men hoed
all day to mark the opening of the planting
season. The African hoe is distinctive by
virtue of having a short handle—useful in
the clay-like earth—which means that the
hoer bends low over his task. The mask
itself, the hoe, and the smith, who makes
both hoe and mask, are united as symbols
in a ritual which celebrates human indus-
try and the earth's fruitful potential.

The smith is the head of the hoeing soci-
ety which organizes the masked rite, and
he is also the one who carves the head-
dress. In finishing the sculptured head-
dress, he treats it as he would the hoe,
laying it beside the fire, working his bel-
lows to blacken it, then adding a red cloth—
the color of glowing metal—and hammer-
ing beaten metal onto it. In sum he repeats
the sequence used in forging the hoe.

As symbols these headdresses can be
seen as tools for better farming. The Afri-
can cultivator relies chiefly on body energy
and a simple tool, the hoe; the African hoe
resembles the carver's adze, a tool not
employed in the European craft of sculp-
ture. Both have a short hardwood handle
and an iron blade set at an acute angle.
Both are produced by the smith.

Hoes are a means for working the
ground in order to produce a more abun-
dant growth of plants than would be avail-

able without the hoe's intervention. Adzes shape wooden sculpture used to produce better results in terms of human effort. Both are techniques to solve a problem: the achievement of good crops and prosperity for the community.

The appearance of the masked figures was a sacred rite to honor the mythical wild creature who brought the knowledge of hoeing to mankind. The dancers, covered with long black fibers, bent over on sticks imitating the industrious cultivator, or pawed the ground like mating antelopes. More recently the festival simply honors the good farmer, and a chorus of women sing of the rewards for the one who works like *tyi wara,* meaning a cultivator—wild animal, an excellent farmer.

The long nose of the carved figure refers to the pangolin, a small animal who survives by burrowing in the ground for his food, like the good hoer. The ears are emphasized because through them youths learn of the exploits of their successful forbears. The celebration makes farm work important, arousing interest in the preliminary hard work essential for eventual results by enhancing it with organized duties, entertainment, extraordinary exploits, inspiring messages in songs, with the added wonder of unusual performing masked figures. The technical importance of the hoe is celebrated as a practical tool; the artistic ritual is addressed to the intangible feelings and sensory responses of the cultivators. These elements link the performance to the past, the forefather farmers, to the greater world outside the village, and by promise of rewards, to the future.

Adams, Monni. Hoes and Headdresses. Paper read at the Triennial African Art Symposium, New York, 1974.
Imperato, J. The Tyi Wara Dance, *African Arts* 4, 1:8-13, 71-80, 1970.
Sketches
Roan antelope (*Hippotragus equinus*)
Gazelle (*Oryx*)
Pangolin, anteater
Aardvaark, anteater
African hornbill
Drawings by Barbara Page, Peabody Museum, Cambridge.

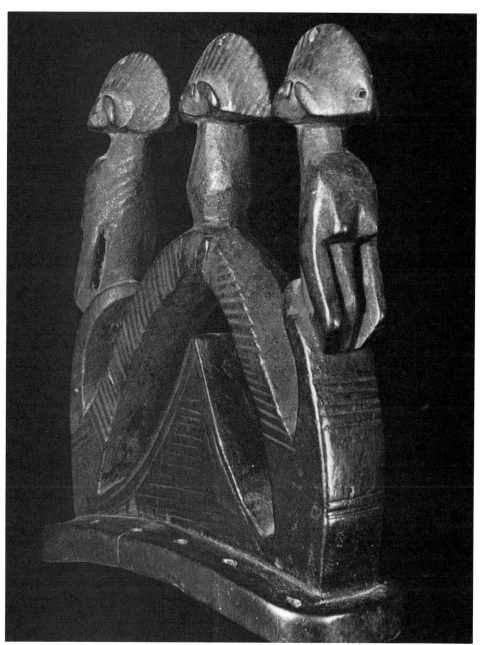

18

18—**Antelope and human figure headdress** (*sogoni-koun*) 7"
Wasalunke, Mali and Guinea
Karob collection—From Aaron Furman, New York, 1976 (collected before 1958)

This kind of headdress (*sogoni koun*—antelope head) was used by dancers in public entertainments organized by the youth association who hired themselves out for field labor. After tilling, weeding, or harvesting, the members would dance animal masquerades for the villager who had hired them. The performance was very acrobatic and the instrumental music and lyrics differed from the *tyi wara* ritual. (A village could possess both.) Female singers praised the performers who they address as the chief of antelopes, the arch symbol of the vigorous wild animal of the grasslands. The *sogoni koun* complex spread to the Bamana in Mali and in some areas combined with *tyi wara* performances.

19—**Composite animal headdress** (*sogoni koun-tyi wara*) 14½"
Southern Bamana, Mali
Lorna Marshall—From J. Klejmann, New York 1958

Several kinds of masked animal figures enlivened the work of cultivating and harvesting in this grassland region. A hyena mask would call out the workers, and at the lunch break perform with a baboon dancer. At the evening meal, the workers would put on a dance masquerade of animal figures including this kind, which unifies desirable features found in various creatures. It represents the aardvaark at the base, above that the pangolin, both anteaters who keep their noses to the ground, and on top, the curved horns of the roan antelope. The single horn refers to the duiker, a small antelope whose quickness and cleverness the chorus urges the dancers to emulate.

Imperato, P. Sogoni Koun, *African Arts* 14, 2:38-47, 72, 1981.

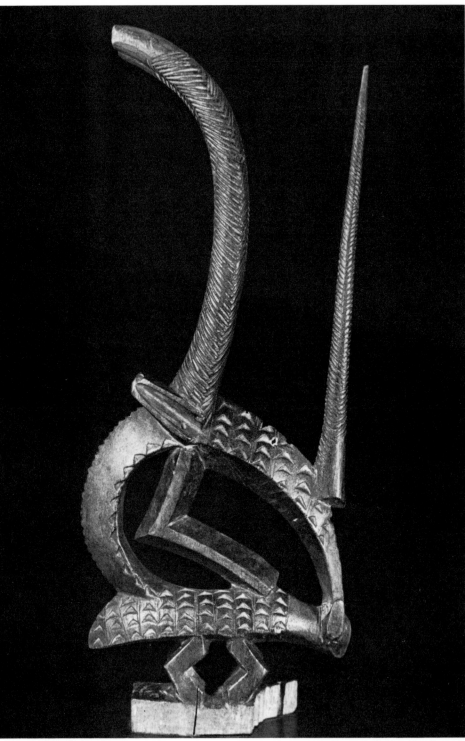

19

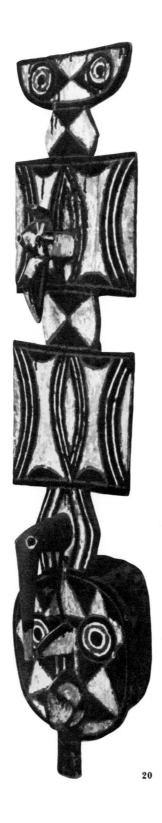

20——**Polychrome panel mask** 54″
Nuna, Upper Volta
Private collection–From AAA Gallery,
Paris, 1969

The Nuna, along with several other small
ethnic groups (Bwa, Sisala, Ko, and Samo),
occupy the sub-Saharan land between the
better-known peoples, the Bobo and the
Mossi, and until recently masks of this
kind were attributed only to the Bobo–
Oule (Bwa).

Nuna masks are considered to be mani-
festations of bush spirits. The various
masks appear in large groups in the vil-
lage once every three years for a three-day
festival attended by numerous spectators
from neighboring villages and sponsored
by the leading lineages (kin groups) in the
village. The sponsors make sacrifices of
their cattle or goats which provide meat
for the feasting. If the masks are properly
received and honored they help assure
good crops.

During the next few days the masks
accompanied by drums and flutes dance
individually before the critical but appre-
ciative eyes of the assembled audience.
Each mask has its own specific name and
dance steps. The plank masks are usually
named for popular sayings or proverbs
which may be chosen by the man who com-
missioned the mask.

Skougstad, N. *Traditional Sculpture from
Upper Volta.* African-American Institute,
New York, 1979.
Skougstad, N. Letter January 19, 1982.

20

Human Fertility

Africans place great value on having many children. From a practical point of view children provide extra labor in agricultural seasons and when grown they are expected to support the elders who no longer work. On an emotional level the achievement of numerous, prosperous progeny creates pride and a sense of social fulfillment. One scholar, C. Bledsoe, has described these values as a "wealth-in-people" system.

From a religious perspective, descendants are important to take care of the funeral rites which assure arrival of the soul to a spirit world where it imparts its essence to future children and acts as a mediator between descendants and the great divinities.

Judging from known collections, female figures outnumber male statues in African art. Women as mothers are prized for their nurturing, just and generous qualities. Perhaps the belief in the power of the ancestors to bring infants and to succor their descendants gives rise to the great number of female statues, especially those shown pregnant or nursing infants. Or just as the ideas about the extraordinary and self-perpetuating fertility of the bush (producing without "labor") leads to the use of symbols from the bush, the power of women naturally to bear children may inspire their representation as symbolic sources of abundance and productivity.

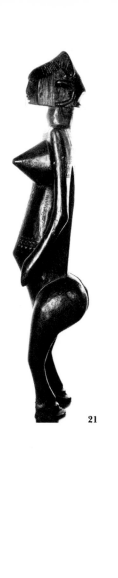

21

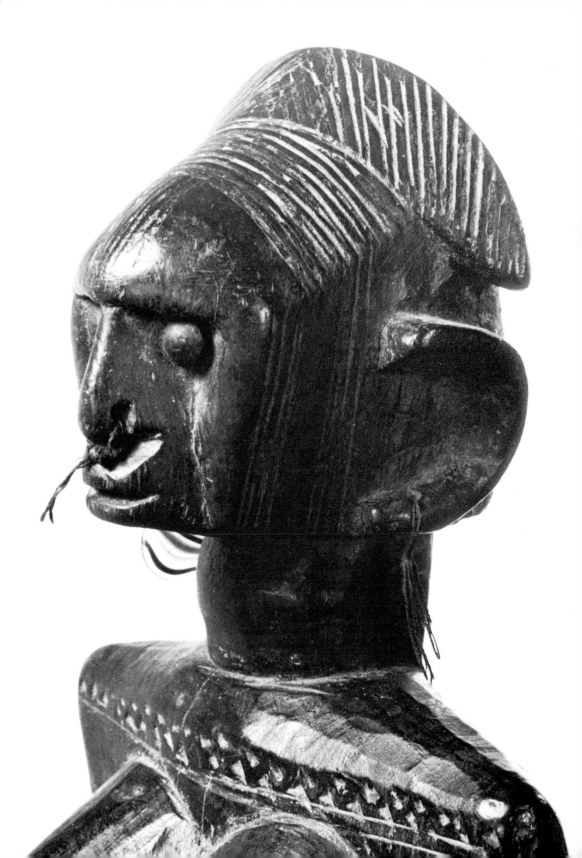

21—Standing female figure 24″
Bamana of Mali
Bardar collection—from J. Klejmann,
New York, 1960

Among a number of peoples in this
region, several sculptured figures appear
at shrines of cult associations. The figures
are either displayed or danced with while
initiating members into the cult group or
appealing to the spirits. Usually there will
be a main pair of male and female figures,
along with a few others such as a woman
holding a bowl or a woman's figure sugges-
tive of pregnancy, such as this one.

The separation of body parts, so consis-
tently a feature of much of African sculp-
ture, is clearly evident in this figure. The
unnaturally short arms increase the
impression of distinct sections. The rigid-
ity of the balanced pose is relieved by the
arc of her headdress, the roundness of her
breasts, and the bent outlines of her arms
and legs. The upper parts of her body are
elaborated and hold our attention. Groom-
ing and scarification, prominent on this
figure, are seen as tributes to one's society
—discomfort endured to please one's fel-
lows. A widespread practice in black
Africa, they are taken as evidence of a
woman's beauty and spiritual strength.
Her full breasts and swelling abdomen
suggest potential fruitfulness. The active
stance of her legs, displayed hands,
squared shoulders, and alert facial expres-
sion convey strength and readiness.

Goldwater, R. *The Bambara.* Museum of
Primitive Art, 1960. Ezra, K. Female Fig-
ure, p. 27-28, in S. Vogel (ed.), *For Spirits
and Kings.* Metropolitan Museum of Art,
New York, 1982.

22—Abstract female figure 8″
Mossi, Upper Volta
Prof. and Mrs. Julian and Doreen Beinart
—From Totem: Menighelli Galleries,
Johannesburg, 1967

23—Abstract female figure 11½″
Mossi, Upper Volta
Private collection—From Alain Schoffel,
Paris, 1978

If a Mossi married woman has trouble
conceiving her first child she places a small
wooden figure into the back of her waist-

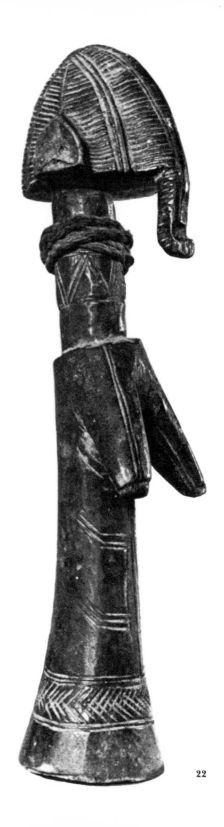

22

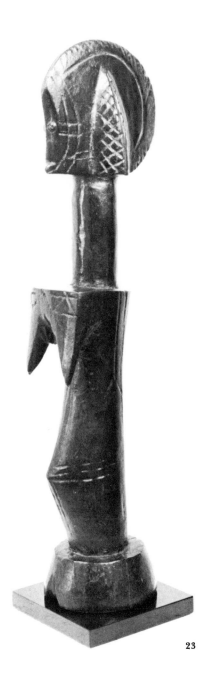

band where should would normally carry her infant. She addresses her appeal for conception to the ancestors or the spirits of the bush. However, the figure does not depict either kind of spirit; it presents the child as the mother hopes it will become. The appendage at the front of the head of the smaller figure represents a braid of hair that unmarried girls wear over the forehead; this type occurs widely among the Mossi. The larger one is in the style of the former kingdom of Boulsa in eastern Mossi country.

If these actions bring a woman luck and she bears a child, she will treat the figure exactly as she does the new infant. She washes and rubs it with palm butter, which gives the wood a fine patina. This care contrasts with the dirty and broken figures which serve little girls as toy-infants to care for and discard. The successful mother would decorate the figure with bits of cloth, beads, and earrings and keep it for many years. These small figures, all of which are female, are carved by smiths and can be either purchased in the market or designed on commission. Women not helped by this means and also those past childbearing age may choose to sell figures they have owned.

Roy, C. Mossi Dolls, *African Arts* 14, 4:47-51, 1981.

24——Round-headed figure with beaded ear pendant *(akuaba)* 11″
Akan, Asante, Ghana
Prof. and Mrs. Willo Von Moltke—Obtained in Kumasi, Ghana, 1967

25——Armless figure with rectangular head shape 9″
Akan, Fanti?, Ghana
Adele and Boris Magasanik

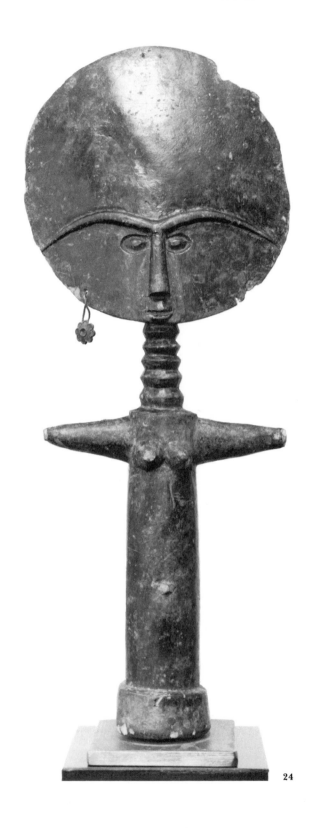

24

25

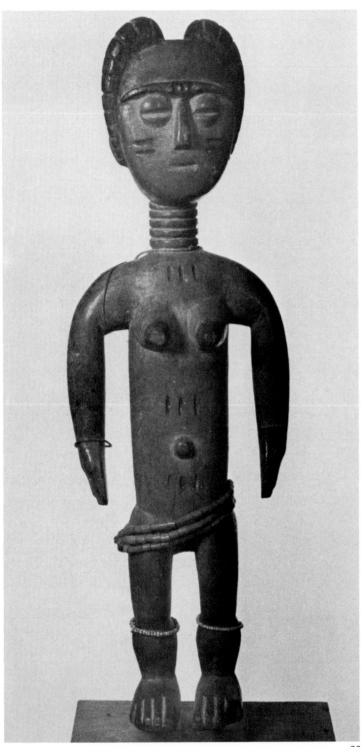

26

26——Standing female figure 12″
Akan, Fanti, Ghana
Mary Ellen Alonso—From the Mirski
Estate, 1976

The best-known use of these small figures
is as an aid to conception, that is, the figure
would be consecrated by a priest who
invokes the influence of his cult deity to
induce pregnancy. The figure is then
carried by a woman for a stated period at
the back of her waist sash.

The flat disc-shaped head is a
convention of the Akan ideal of beauty: a
high oval forehead, slightly flattened in
actual practice by modeling of an infant's
soft cranial bones. Women already
pregnant may carry such a figure to
ensure safe delivery and an attractive
child. If the birth is a success, the figure
may be returned to the priest's shrine as a
thank offering.

Cole, H. and D. Ross. *The Arts of Ghana.*
Museum of Cultural History, Los Angeles,
1977.

27——Three twin figures *eri ibedji* 11″ 12″
9½″
Yoruba, Nigeria (Ekiti, Oyo Egbado/Egba)
Boris Senior—From Arcade Gallery,
London, 1968

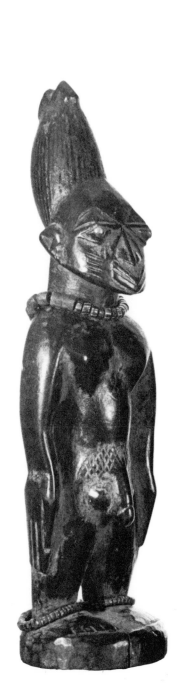
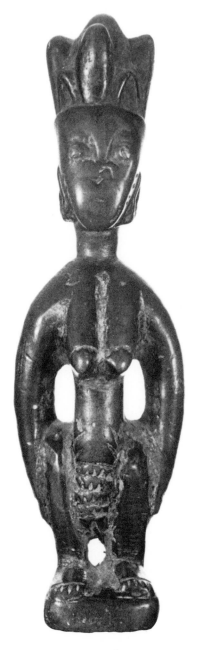
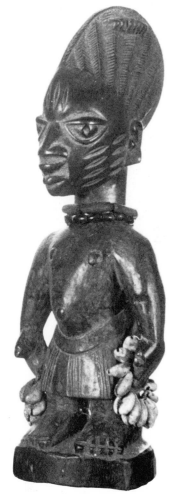

27

28—Twin figure 11½"
Yoruba, Nigeria
Herbert C. and Rose B. Kelman—Obtained near Ibadan, Nigeria, 1963; registered with National Museum, Lagos

29—Twin figure 10½"
Yoruba, Nigeria
Karob collection—Acquired in Paris, 1973

The Yoruba hold many beliefs about the sacredness of children. Nowhere are these ideas expressed more vividly than in the Yoruba's treatment of twins. The several million Yoruba living in southwestern Nigeria have the highest twin birthrate in the world, occurring in 45.1 births per 1,000 (compared with 11 per 1,000 in the United States).

These twin statuettes are commissioned by a mother if one or both of her twins should die. The carved wood statuettes serve as substitutes, which she cares for, periodically washing the little figures, adorning them with cosmetic red and blue pigments, and on festival days offering them bits of food. The face and parts of the body may be worn smooth by this handling. By continuing this special care, she hopes the twins will be attracted back and be reborn to her. Although deceased at a young age, the twins are represented in their statuettes as adults, a stage it is hoped they will reach when they return.

In response to the frequency of twins and the high infant mortality rate, the Yoruba have over the years commissioned thousands of twin sculptures.

Houlberg, M. Ibeji Images of the Yoruba, *African Arts* 7, 1:20-27, 1973.
Siroto. L. Twins of Yorubaland, *Field Museum Bulletin* 38:4-8, 1967.

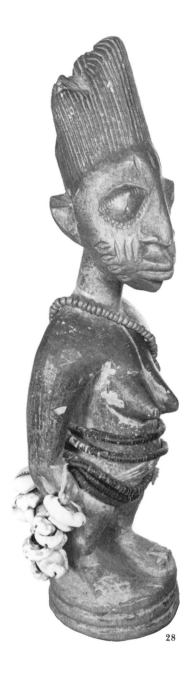

28

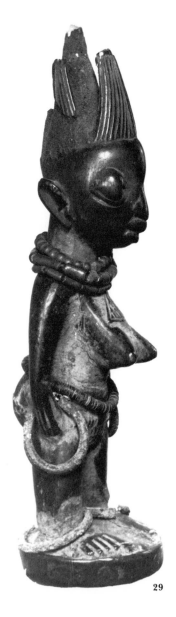

29

A Design for Gender

Social Definition of Men Through Ritual: Boys' Initiation

The division of labor between men and women is a fundamental structure in the small agricultural societies of black Africa. It is important therefore to impress on young people their social identity as male or female, and maintain the distinction between these two categories. Many African communities carry out this intensification of identity by designing a ritual of initiation for children, beginning at the age of 8 to 13. Usually this ritual is more prolonged and elaborate for boys, perhaps because they must shift their concerns and loyalties from the intimate sphere of their mothers to take up the dangerous roles of clearers of the land, warriors, and hunters.

Artistic activities are an integral part of the initiation process. The boys learn the secrets of the masks, including how to make them, and the dances, songs, and verbal arts appropriate to men. Older initiated men wear masks to direct secret rites, to make dramatic appearances at certain public celebrations, and to manage the initiation camp itself. Art forms thus provide part of the lore which distinguished man from boy, and serve as the medium for communicating this knowledge.

Boys gathered together from many villages would be under the care of two basic types of masks, whose contrast in facial form signals a difference in character. One kind exhibits strong projecting features or mixes human and animal motifs; it performs in a vigorous or authoritarian role, considered masculine. The other, more delicate in facial type, behaves in a more refined mode and in some instances is called the "wife" of the forceful mask. However, all the masks are worn by men.

Wooden masks are only part of the inventory of masking; there are many leaf, fiber, and cloth masks used in rituals. The body of the mask wearer is usually thickly covered with strips of fiber, and sometimes cloth is added, to disguise the human form and to project an impressive, aggrandized spirit presence.

In the region where the three states, Liberia, Guinea, and Ivory Coast, meet the various ethnic groups hold an initiation for boys that lasts several years. Among the Mano and Bandi, whose masks are exhibited here, initiation is an essential step in joining a hierarchical order of men usually referred to as the Poro, an archetypical secret society, which in this region is a powerful institution with wide-ranging economic and political interests. The clever and courageous behavior of the boys in the camp is exceptionally important because their potential within the Poro organization will have a significant effect on their later opportunities and standing in society.

During initiation, conditions of ordinary life are reversed for the candidates. The boys live in the forest instead of the village, and they are not supposed to be fed by their mothers. In the forest they are circumcised and marked with certain scars, said to be the teeth marks of the mythic forest demon who swallows them and gives them rebirth as Poro men.

The boys are taught the rules of adult men and above all loyalty to the men's society. Discipline is terrifyingly strict. The strong-featured masks take on the disciplinary and punishment tasks. This disguise enables the men to perform not as private individuals but as special spirit personalities who come from the forested mountains. This spiritual role enhances their authority and if they inflict punishment, it removes personal blame.

Masks exhibiting the two different types of features and behavior are also worn in dance and song sessions and engage in dramatic interaction with the boys, who test their daring by trying to approach the forceful, energetic ones. Of course, the boys learn that the masks are being worn by men of the village. However, they must never reveal this secret to women, and no one-may publicly acknowledge the identity of the wearer of a mask.

Masks of the fine and fierce types are produced by other ethnic groups in this tri-state region, such as the Dan and Wee (formerly called Ngere or Kran) and they also play their parts in boys' initiation. However, there is no formal continuing organization such as the Poro

in charge of initiation. Boys are gathered together for a short period in a bush camp mainly for circumcision. The unseen forest demon who claims to give them rebirth does not leave scarification marks. The elders who take up duties at the camp share no membership or permanent links that would define a boy's future place in society.

One of the best-known masks of the initiation camp in this region is a delicate type that takes the role of a surrogate mother and goes to the village to cajole the women into giving food, which it delivers to the camp. Despite its refined appearance, the mask reveals ignorance of village life. When begging food from the women, who are mothers of the boys, it is offered in a teasing manner chaff instead of grain. Although a creature of mediation which moves from forest to village, it still remains a wild spirit. Yet it cajoles rather than threatens, thus winning the allegiance of the women to the initiation process.

The pattern which emerged in masking at agricultural festivals of bringing the vitality of the bush into the village is reversed in this initiation process, as the boys spend an ambiguous, liminal period of their lives in isolated seclusion in initiation camps in the forest. The mysterious powers of the bush are drawn on to "grow" the youths into men. Their passage will be guided by masked bush spirits rather than by humans in an environment relatively free of the orderly categories which characterize village social life.

30 — Face mask 8½″
Konor, southeastern Guinea
Karob collection – Acquired by
Dr. George W. Harley in Liberia
before 1948

This fine-featured mask shows a skillfully arranged contrast between gently curving surfaces and edges of gradually increasing prominence: delicate edges at the eyelids, more blunt at the end of the nose, and expansive at the lips. Another sensitive relationship lies in the upward curve of the upper lip and the fullness of the mouth which counterbalance the downward tendencies of the lower lids and nose. These counterpoints of form sustain interest in looking at the face. The holes at the sides and the iron hook at the chin serve to fasten the upper part of the costume in place.

Harley, who collected the mask, wrote the word "Konor" on the inside of the mask. However, the style could as well be attributed to the southern Mano. Masks of the two basic types of strong and delicate features are used by both groups for social control purposes, including boys' initiation. In any case, this delicate featured mask was conceived as a surrogate mother for the boys in the initiation camp.

Holas, B. *Les masques Kono.* 1952.

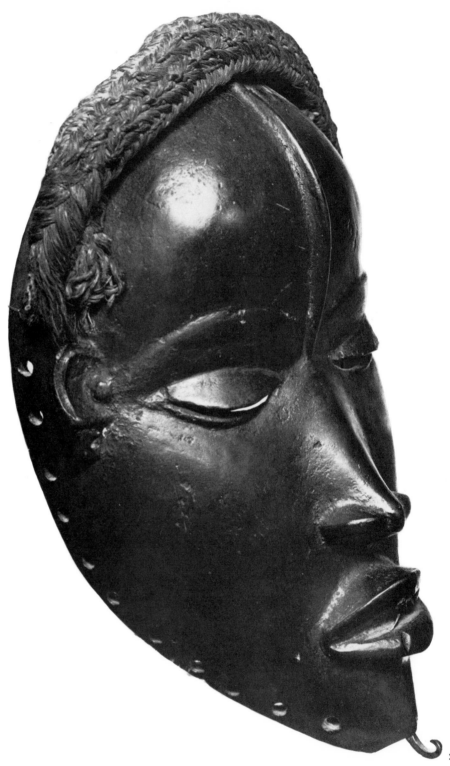

30

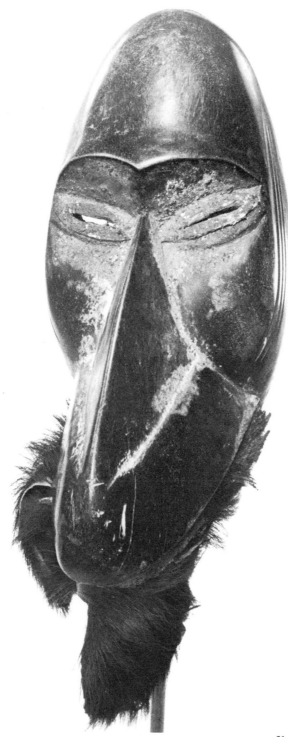

31—Mask with extended nose 12½″
Northern Mano, Liberia
Genevieve McMillan

The broad-nosed mask with narrow eyes is
a rare example, as masks from the north-
ern Mano have not been popularized by
readily available copies. Typical of the
frightening, long-nosed masks used for
several purposes by the Poro society, this
mask is made of thick, dense wood with a
fine patina showing wear. The pieces of
fur attached to the jaw are new but this
material often has to be replaced because
of insect damage. It resembles the mask of
the circumciser specialist, which was col-
lected by Zetterström in the early 1970s
in northern Liberia (see 1980: Fig. 7),
although details of the brow and nose dif-
fer slightly. However, the kola nut paste on
the face suggests a more sacred role, as this
is done to the mask of the *Ge go,* the most
important Poro official. He is fully cos-
tumed only on special occasions, such as
when the boys enter and leave the Poro
bush or when a big Poro official has died.
He presides in all matters concerning the
Poro and it is unlikely that the town chief
would make an important decision without
consulting the *Ge go.* He commissions the
masks for Poro and makes sacrifices to
them as the seats of spirits of previous
Poro specialists. He is a much feared medi-
cine man.

Zetterström, K. Poro of the Yamein Mano,
Liberia, *Ethnologische Zeitschrift* 1980,
no. 1: 41-49.
Zetterström, K. Letter April 8, 1982.

31

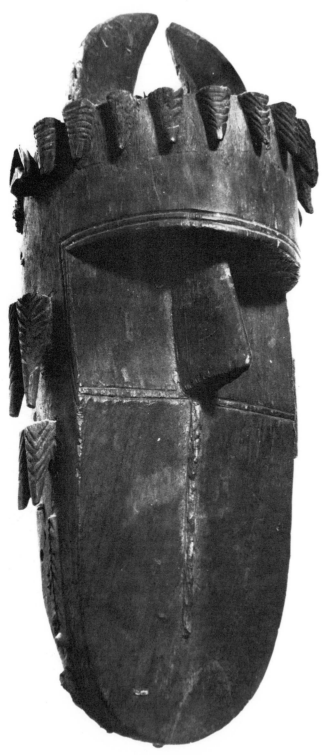

32 — Broad-faced mask with horns 21″
Bandi, Liberia
Karob collection—From Rene Guyot,
Monrovia, Liberia, 1977

Further to the west and northwest, among
the Kissi, Loma, and Bandi, the masks
controlling boys' initiation exhibit a differ-
ent character from the Mano. The third
mask in this section represents the severe-
looking "wife" of a big forest demon
among the Bandi of Liberia, where the
Poro society is strong. The Poro masks of
this area are much larger than the Mano
masks, and the features of the 'female' type
are abruptly separated, without the gently
modulated facial planes that give the
masks of the eastern sectors a subtly femi-
nine appearance. Her exact duties are
unclear but her mate makes a most dra-
matic appearance during the initiation
period (see sketches). He comes into the
village in the form of a long-jawed, horned
mask-figure, wearing the mask horizon-
tally on top of the head, his body covered
by a bulky fiber costume. In the village
square he demonstrates his power to
devour by taking under his costume one of
the initiates he has brought with him and
then squeezing out red juices through his
great teeth.

Harley, G. *Masks as Agents of Social Control.*
Peabody Museum Papers 32, 2, 1950.
Dennis, B. The Gbandes. 1972.
Male forest spirit mask, Bandi
(Harley 1950).

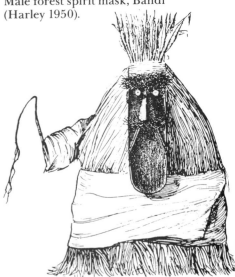

32

33 — Tall, polychromed mask with horns
5′
Bobo, Upper Volta
Private collection – Acquired in
Upper Volta in 1958
Photo credit: Hillel Burger

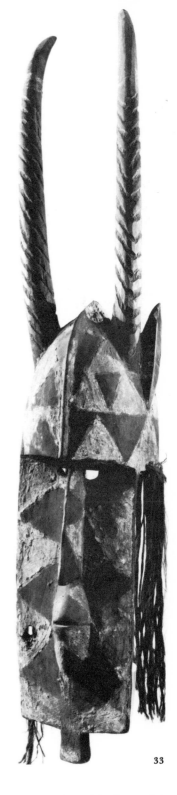

33

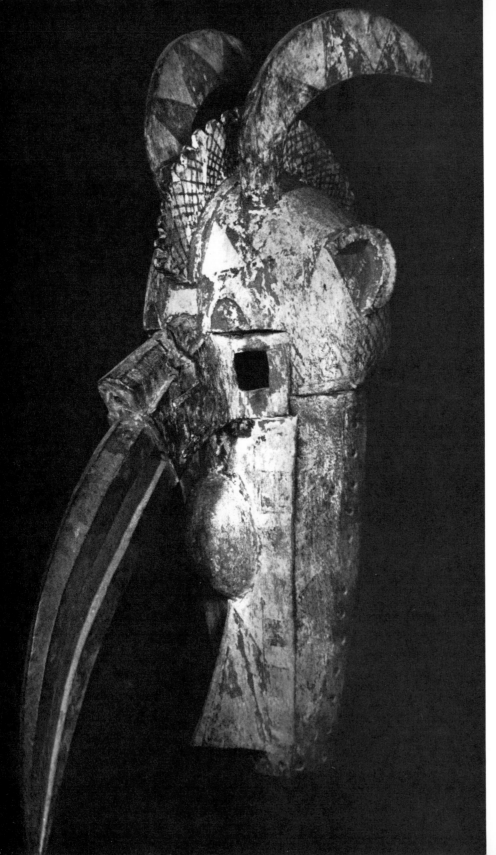

34—Polychromed mask with beak 29″
Bobo, Upper Volta
Drs. Carolyn and Eli Newberger—
Obtained in Bobo Dioulasso,
Upper Volta, 1968

Within the villages of the Bobo, young
men of 13 to 27 organize themselves into
six age classes in order gradually to
acquire the knowledge responsible adult
men should have. Every few years a series
of festivals mark the entry of the youngest
boys into the system and the promotion of
the others. The cultivators and black-
smiths celebrate with masks of leaves and
fibers; the blacksmiths also bring out
masks of wood, such as the examples here,
which combine human and animal fea-
tures. The first displays antelope horns,
the second the beak of a hornbill, a large
clever bird.

 The initiation rites, controlled by youth
of a higher grade, tests the character of the
boys by severe physical hardships and dis-
ciplines them by precise codes of behavior,
especially toward their elders. The effect is
to define standards for men's conduct.
They learn a secret language and the use
of metaphoric speech. An important part
of the religious knowledge they acquire
relates to the origin and significance of
masks as a series of manifestations of the
major deity Wuro and his avatar Dwo.

LeMoal, G. *Les Bobo: Nature et fonction des
masques.* ORSTROM, Libreville, 1980.

35 — Wood and basketry mask with stuffed animal form 22½"
Northern Yaka, Kwango sector, western Zaire
Genevieve McMillan — Purchased in Brussels, 1959

Of the eight types of masks that appear to celebrate the end of boys' initiation, this kind, the *kholuka,* is the most popular. Its appearance at the end of a series of dances is eagerly awaited by the assembled community. The *kholuka* is worn by a camp official and his songs, repeated by the crowd, link the imagery of the mask to abusive mockery of a range of community figures from the regional chief to thieves, all charged with humor. In this mockery, women above all are disparaged—perhaps as an affirmation of male solidarity and the more dominant role the young men will seek. The other types of masks are worn by outstanding initiates. Masks are seen as protective charms for the boys against dangers, such as their initial contact with women.

If one asks the sculptor about the puppet-like images on the top of a *kholuka* mask, he will say it is decorative. But the *kholuka* dancer's actions and his sung verses make clear that the meanings are predominantly sexual. Most of the puppets display explicit sexual themes. Even the downward peering stance of this strange monkey would be coupled with mockery of someone's insatiable sexual curiosity.

The upturned nose of the face refers to an elephant's trunk. The initiation cabin and its major charm are also associated with the elephant, which is emphasized not for its size but its ability to insert its trunk into cavities. One of the secrets learned in initiation is that the upturned nose stands for procreative sexuality, a good example of the analogical style of thinking at the basis of much of the visual symbolism. In view of the style, especially the broad-based nose and stalk-like eyes with rounded extremities, this mask likely derives from the Munene region between the Kwango and Tuana rivers.

Bourgeois, A. Yaka Masks and Sexual Imagery, *African Arts* 15, 2:47-50, 87, 1982.
Bourgeois, A. Letter May 5, 1982.

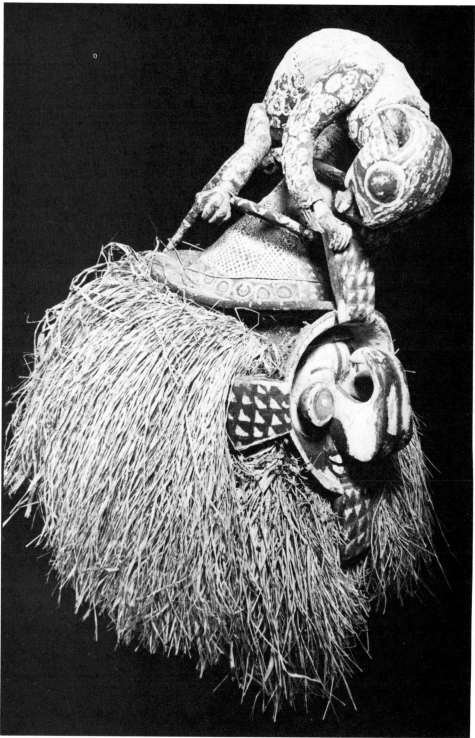

Social Definition of Women Through Ritual: Girls' Initiation

In one region of West Africa the initiation of girls is outstanding for its highly organized character and for its use of masks worn by women. This is the only region in Africa where masks are donned by women— and the only art tradition in the world in which women wear masks while carrying out important social tasks. The masks are commissioned from male carvers. Several ethnic groups in Liberia and Sierra Leone share this custom and three of them are represented in this exhibit: Mende, Gola, and Bassa.

The women's society, called Sande or Bundu, is organized with a hierarchy of officials who control the initiation ritual for girls. These officials also enforce the rules relating to treatment of women generally in the community. Young girls may spend up to three or four years in the special houses of the society near the village. Their labor is available to Sande officials and adds to the wealth of the society. At their coming out, the graduates become desirable wives as a result of their special training.

In my view the aim of the Sande society is control: control by the society over the marriages and activities of the local women—Sande claims control over birth itself—and control by the older women over the younger ones, and control over the self as an ideal of spiritual per- fection. We see a forceful statement of Sande's power of control in the use of black hood masks, which represent forest spirits. Their blackness stems from their association with deep pools in the forest. In local belief, the forest, a place of potential fortune and of danger, is inhab- ited by spirits who are normally invisible. If one were to meet a forest spirit there, one would undergo some kind of transformation: become rich and powerful or go mad. The Sande society brings these danger- ous forest spirits into the village as beautifully groomed mask forms and submits them to the discipline of measured dance. On the other hand, the society takes the normally harmless, visible girls away into the forest and transforms them in a series of rituals from "inept novice" to "maidens" to "brides" and returns them to the village in carefully con-

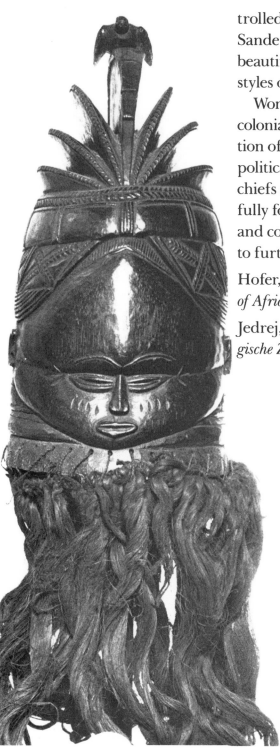

trolled form to become wives. The control sought and achieved by Sande is typified by its most dramatic representative and symbol, the beautifully groomed mask. The artifice and elaboration of the hairstyles of the women and the masks is a visual metaphor for control.

Women's role in Mende society is especially significant, as in precolonial times (prior to the 20th century) women could hold the position of chief of a village cluster, and they have been able to translate this political role into modern government where 12 percent of the elected chiefs are women. Pregnant and lactating women campaign successfully for office. Today 95 percent of women belong to these societies and contemporary women politicians continue to use the Sande society to further their careers.

Hofer, C. Sherbro and Mende Women in High Office, *Canadian Journal of African Studies* 6, 2:151-164, 1972.

Jedrej, M. Structural Aspects of a West African Secret Society, *Ethnologische Zeitschrift* 1980, no. 1: 133–141.

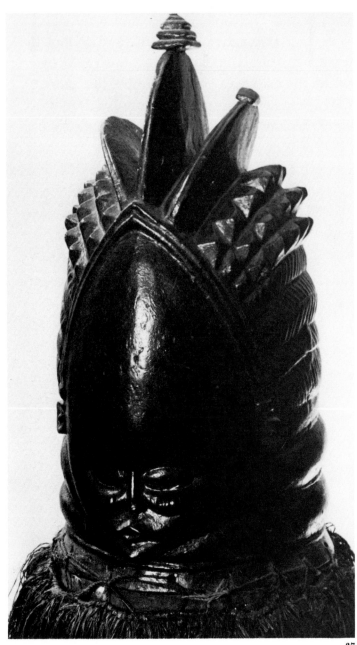

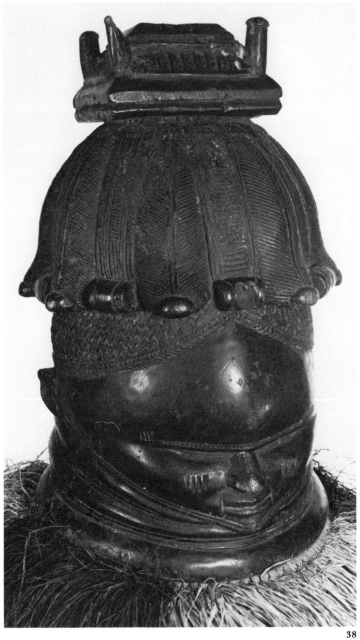

37

38

36——Black hood mask with bird on top
16½"
Mende, Sierra Leone
Genevieve McMillan

37——Black hood mask with three-flanged hairstyle 17"
Mende, Sierra Leone
Karob collection—From Mario Meneghini, Monrovia, Liberia, 1966

38——Black hood mask with square ornament on top (upper part damaged)
15½"
Mende, Sierra Leone
George Wald

The hood mask presents an ideal of feminine beauty admired by the Sande society; intricate hairstyle, broad forehead, and delicate features. The gleaming surface signifies healthy glowing skin. According to Sylvia Boone's informants, the indented rings around the neck are seen as an added touch of beauty—serving no physical function, they are a mark of beauty given by God. The neck is broad in order to fit over the head. (In contrast, sculptured figures show a ringed neck that is very narrow in proportion to the head and shoulders.) The carving is smoothed with the rough leaves of the ficus tree, then dyed black with a concoction made from leaves. Before use, it is anointed with palm oil to add shine. (Modern carvers use shoe polish.) The elaboration of the upper part of the hood represents one of the fancy hairstyles that were actually in vogue in the early part of the century, although the lobes of hair were thicker than in the carving style. With this confining mask, the wearer who is a good dancer and an official of the women's society, also puts on a heavy cotton costume covered with heavy fiber strands dyed black. The bird on top of the mask declares her ability to dance with light feet.

According to recent fieldwork by Ruth Phillips, the first mask in this set is an old style, probably from western or central Mendeland. The second shows a clearly defined treatment of cheeks, chin, and pursed mouth in a mannered style dated to about 1910 in central Mendeland. The style of the third example dates to about 1950 to 1955; other masks resembling it have been documented in and around the small Bo chiefdom in east-central Mendeland and one was acquired by the Pitt Rivers Museum in 1957 (7.01). Showing photographs of various masks to Mende people, Phillips found this type the most popular in the early seventies, because of its naturalism and fine hairstyle. Masks of these three styles are still in use in Mendeland.

Phillips, R. The Iconography of the Mende Sowei Mask, *Ethnologische Zeitschrift* 1980, no. 1: 113-132, illus.
Phillips, R. Letter April 26, 1982.
Boone, S. Lecture given at Harvard University, April 22, 1980.

39——Standing female figure in costume
26"
Mende, Sierra Leone
Genevieve McMillan

This figure exemplifies the fully developed Sande society member. She wears necklace and waist ornaments characteristic of the initiated woman. It can be dated to around 1905, as it closely resembles the style of masks in central and eastern Mendeland (especially a Koribondo type), which show the same hairstyle, bulging forehead, and facial features. Of varying size, such figures were owned by people of status, as part of the decoration of their household. They were frequently depicted wearing garments such as European trousers, often boots too, especially in that early period when these items were presumably prestigious. As these figures do not have a ritual context, being more of a prestige symbol of personal accomplishment, they are more easily obtained by traders. (In western Mende and Sherbro chiefdoms, such sculptures did have ritual use, particularly as guardian figures).

Phillips, R. Letter April 26, 1981.

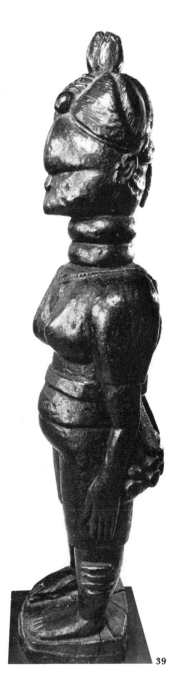

39

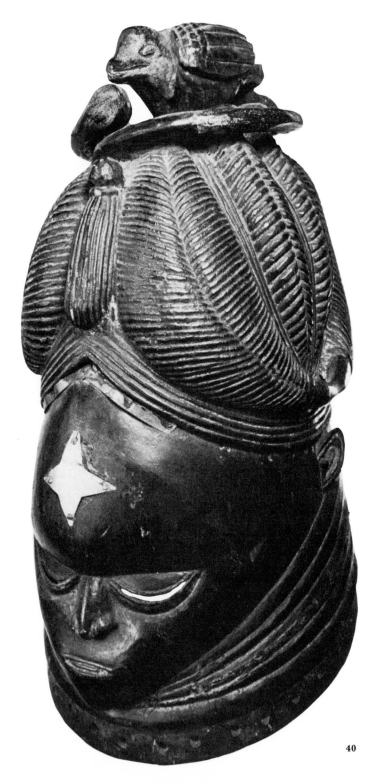

40—**Black hood mask** 14½″
Gola, Sierra Leone
Genevieve McMillan

Several masks surmounted by a bird and
snake motif have been attributed to the
Gola, who possess a strong type of Sande
organization for women, whose officials
also dance with black hood masks. Phillips
documented a mask of this style in a Gola
town in the Pujehun district, Sierra Leone.
The carver, Lansumana Ngumoi (*ngumoi*,
wood-man), worked around 1915. This
type is also produced by a contemporary
carver.

41—**Black hood mask** 16″
Bassa, Liberia
Richard Lizdenis, Osterville, Ma.—From
Rene Guyot, Monrovia, Liberia, 1972

Hood masks of the Bassa are not common
in collections. The mask is worn by a
female official of the womens' society of
the Sande type, which is also known among
several other ethnic groups of Liberia such
as the Vai, Gola, Kpelle, and Dei. This
mask comes from an area some 50 miles
northwest of Buchanan, which is the capi-
tal town of Grand Bassa County. The for-
mal geometry of the style gives the mask a
special visual appeal. The acute triangle of
the forehead intrudes on the rounded
lobes of the hairstyle; the small circular
projections of the mouth, eyebrows, ears,
and neck help to link the severe planes of
the face with the cylindrical hood.

42—**Black hood mask** 13″
Bassa, subgroup Mahasah, Liberia
Richard Lizdenis, Osterville, Ma.

This example, another version of the type
worn by officials of the women's society,
comes from the Marshall territory, an area
situated between Monrovia and Buch-
anan, two towns on the coast of Liberia.
According to Griba, an old Bassa infor-
mant, the carved hand on each side of the
head should help keep the mask firmly on
the dancer's head, as the human identity of
the dancer must not be revealed. If the
mask were to fall down during the per-
formance the dancer would have to die.

Meneghini, Mario. The Bassa Mask,
African Arts 6, 1:44-48, 88, 1972.
Meneghini, Mario. Letter April 24, 1982.

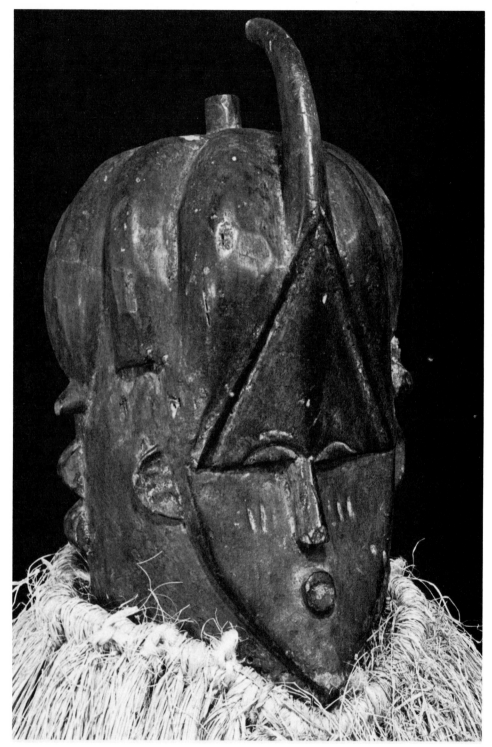

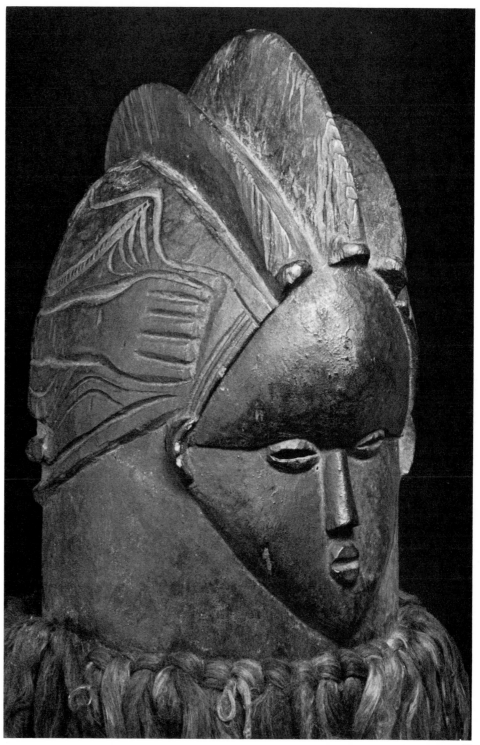

Art and the Community

Task Forces for the Community

In most village communities there are a number of organized social groups, such as clusters of kin, council of elders, general men's association, age classes, medicine societies, diviners, hunters, and dance groups. The heads of these social units hold limited authority in specific matters. We could describe the structure of power as a mosaic of leadership, as a system of composite authority. There is no central figure or institution with a monopoly of force, nor as in African kingdoms, a centralized locus of political power. Where authority is dispersed, it could be difficult at times to suppress insubordination, to enforce village-wide rules, to adjudicate between groups, to require labor for communal tasks, or to share ideal models of behavior and values. As has been touched upon in the discussion of founders and prosperity, some communities draw on spiritual forces for aid in such social tasks.

One of the dramatic ways to call on the spirits to help with these tasks is for certain adults to accept roles of public authority but carry them out wearing masks and costumes, as if they were spirits from outside the village, such as the bush or other places. Fundamentally the mask is to indicate the presence of a spirit, which legitimizes the authority of the costumed figure and exculpates the individual wearer from blame or retribution. Usually there is an association of men or a secret society behind the appearance of the masked figure or a group of assistants: musician, guide, dresser, speaker and so forth, so the role is not taken by an isolated individual but is backed by some kind of social unit.

The use of masked figures to perform public roles and duties seems to be more frequent or more likely where social units, such as kin or gender groups, feel a high tension or are especially competitive in spirit. In such situations, the art forms, such as the costumed mask figure and its special dramatic behavior, disguise the person exercising public authority. This use of art to "mask" the exercise of authority contrasts with the function of art forms in centralized royal courts in black Africa where all the art points to the holder of power and makes

clear the locus of ultimate authority. However, masking has a double aspect: it disguises but it also displays. It projects a different persona from the wearer. In African masking this persona draws its vitality from spiritual forces outside the community, thus providing the social unit presenting the mask with a powerful but indirect method of gaining authority.

The basis for the masked figures' authority lies fundamentally in the respect for spirit forces, along with psychological effectiveness and in some instances secret or public powers of punishment. Strong statements of community values are made by the appearance and behavior of many masked figures when they perform at communal festivities, singing and dancing in manners appropriate and ideal for men or women or exhibiting anti-social behavior which people enjoy watching but learn to eschew, or which maintains fear of the sponsors who control the masking.

Of all the parts of the human body, the face is the most compelling focus of interest. No other art tradition in the world has produced so many versions of the face in masks as the black Africans. The masks arouse our admiration for their immediate impact on our senses, and then we admire them for their variety, their range from strong, jagged rhythms to refined, delicate harmonies of form. There are a number of different ways of wearing masks: over the face, as a hood or cap crest, and on top of the head. Typically masks are worn with a costume that enlarges and distorts the figure of the human wearer.

Two distinct expressive facial types recur in the African mask traditions: one comprised of harsh, ugly, or exaggerated human or animal features, the other, finely finished human features. The total complex that goes with the carved mask—the costume, accessories, behavior, and dancing style—intensify this contrast. Although the two types seem to correlate with models of gender behavior, the basic duality may be developed to express more intricate themes as well. The deliberate mixture of these features is used to convey special symbolic messages.

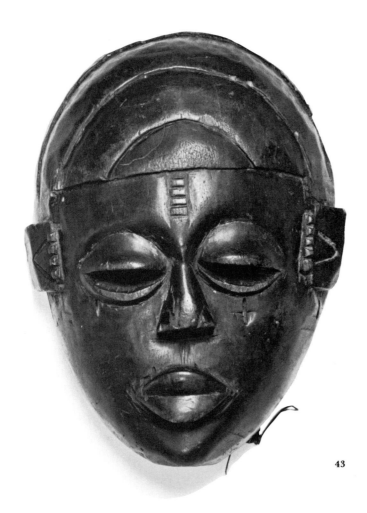

43

Fine and Fierce: Ideal Social Types

43 — **Delicate face mask** 10½"
Ibibio, southeastern Nigeria
Private collection – From Bernheimer's
Antique Art, Cambridge, 1968

44 — **Distorted face mask** 10½"
Ibibio, southeastern Nigeria
Karob collection – From W. Randel,
New York, 1976

In southeastern Nigeria two ideal social types are repeatedly exhibited in mask form. The two masks from the Ibibio illustrate a contrast in style which stands also for a difference in moral character. These masks represent ghosts of the dead, *ekpo,* who in this form return from beneath the earth to visit their families every year after harvest, bringing either pleasure or disaster in an exaggerated reflection of social conduct.

The mask with delicate features is usually painted for public appearance in light colors, white or yellow, and is worn with a costume of expensive bright cloths, in the fashion of young women ready for marriage. It is called *mfon ekpo, mfon* meaning both beautiful and good in a moral sense, referring to those who led good, moral lives and received proper funerals. The other mask with blackened features distorted by a tropical disease and marked by puffed cheeks – symbols of ugliness – is called *idiok ekpo, idiok* meaning ugly and bad. It represents criminals and those who died violent or unnatural deaths, whose restless souls are believed to bring disorder and sickness upon the community. These antithetical masks, both worn by men, should not encounter one another in performance. The *mfon ekpo* dancers retire before the ugly ones appear. Their behaviors complete the contrast: *mfon* maskers move slowly and gracefully with articulated steps as they display their costume and ornaments of high status. The actions of *idiok* are wayward, violent, and irresponsible. The masker shakes its body, runs through the village, climbing houses and trees, destroys property, and shoots arrows at women. The *idiok* are more numerous than the beautiful type. In

the past these frightening figures were the enforcers who carried out punishments ordered by the leaders of the *ekpo* association.

Messenger, J. The Carver in Anang Society, in Warren D'Azevedo (ed.), *The Traditional Artist in African Societies,* pp. 101-21, 1973.

45 — Delicate featured hood mask 17″
Northern Igbo, Nigeria
Private collection—From Pace Gallery, New York, 1979

46 — Composite animal-headed horizontal mask 20½″
Northeastern Igbo, Izi subgroup, Nigeria
Private collection—From Primitive Man Gallery, New Orleans, 1979 (attributed to Ekkphahia subgroup)

Masquerades among the northern Igbo were produced by the several age classes of young men. In such a large population (numbering several million early in the century), there are considerable variations in ritual organization, but the masks consistently display the beauty-and-beast contrast. They possess also a special aura from their association with the world of the dead, and in some areas with the female earth deity who is the supreme judge of men's morality.

The masked figures appear at the main festival of the year after harvest, at the later feast for the earth deity, and at the festivities marking the young men's shift to higher age classes, thus at times when the whole community is assembled or living face to face.

The dramatic aspect of the masquerades is developed in this region and the skill of performers in the various skits is of great public interest. The skits deal with three major themes: the tension between men and women, between the older leaders and the young males, and between personal competitiveness and community harmony. The masked performances and songs criticize and parody greedy and disputatious elders, henpecked husbands, and ambitious women. The beauty masks, classed mainly as daughters, mothers, and grandmothers, are numerous and do most of the acting and dancing, parodying women at

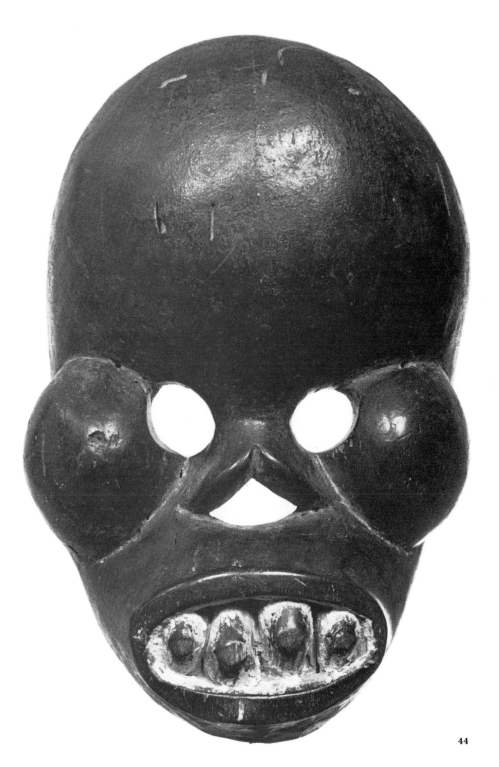

44

work and at leisure. Fathers and policemen may also appear in these skits as white-faced masks, but they lack the elaborate hairstyle.

The delicate featured face here shows the typical conventions of Igbo beauty masks: eyes reduced to horizontal slits, nose prominent with thin nostrils and sharp bridge, lips thin with small teeth showing. The elaborate central arc forms a crest hairstyle that marks female characters. The presence of the two leopard images, which usually symbolize male strength, may indicate exceptional powers for this mask spirit. Before performances, the face would be repainted with white pigment and touches of black and yellow.

Igbo masks standing for male energy and aggressiveness exhibit large, distorted dark-colored faces with horns or combinations of animal and human features in masks worn horizontally on top of the head. The large mask here combines a suggestion of a human face in the long pointed nose with features abstracted from an elephant head: the large ears, the long trunk projecting from the forehead, and the two tusks. This particular type is known from the Izi subgroup around Abakaliki, but it resembles other "sky-ward-facing" masks which combine human and exaggerated animal features. These depict fierce ghosts of men who in life were lawbreakers or otherwise harmful. They do not dance but like other distorted masks run through the village arousing fear and excitement by threatening violence and disorder.

Boston, J. Some Northern Ibo Masquerades, *Journal, Royal Anthropological Society of Great Britain,* 90:54-65, 1960.
Neyt, J. Masque-éléphant et statuaire Igbo, *Arts d'Afriaque Noire* 32:29-45, 1979.
Blier, S. Beauty and the Beast in D. Fraser (ed.), *African Art as Philosophy,* pp. 107-113, 1974.

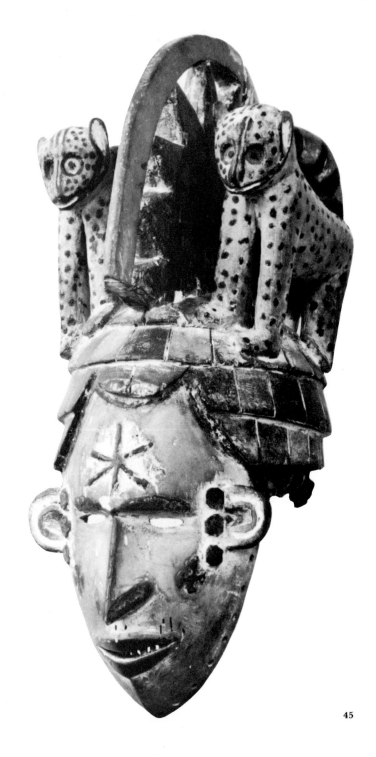

45

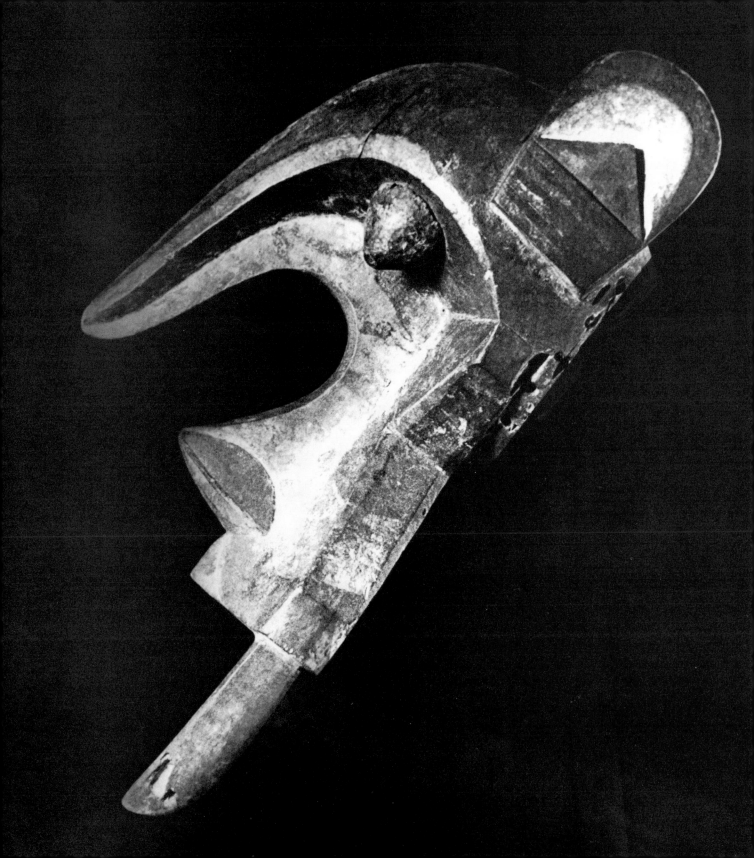

Social Roles Performed in Disguise

The wearing of masks to perform social roles in the community is one of the strongest and most visible efforts by groups of men to declare symbolically their powers to other men and to women. Although the use of masking is often referred to as a form of social control, meaning the achievement of social purposes without the use of force, in many instances the effectiveness of a masked figure is backed by the implicit threat of spiritual retribution and by execution of deviants or recalcitrants, all the more frightening because of the secrecy that surrounds the masking complex. Given the secrecy, it is not surprising that abuses of mask-power are known.

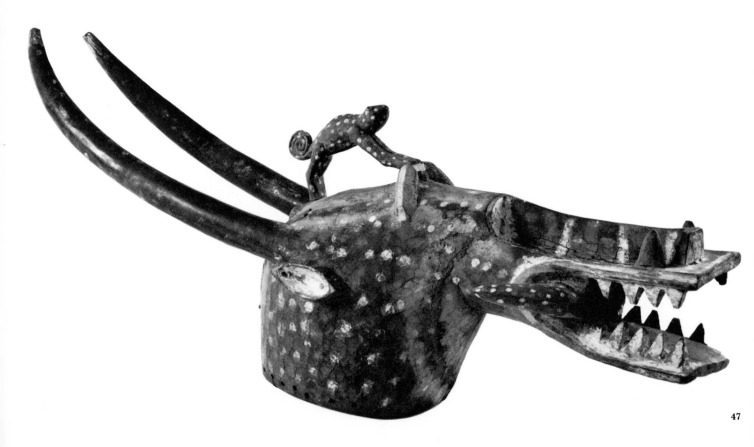

47

47 — Composite animal-headed hood mask 3'11"
Senufo, Ivory Coast
Private collection — Collected in Upper Volta in 1958

Among the Senufo appearance of this kind of forceful featured mask is controlled by the Poro society, an association of graded ranks into which all men are inducted. Its leaders take on responsibility for the stability and continuity of the village order.

The death of an important person in the community is seen as a serious social disruption and the deceased's passage to the land of the ancestors as a dangerous and difficult task. The ultimate demonstration of spiritual power for this kind of mask is to open the way to acceptance of a dead elder into the ancestral world. The funeral rites thus provide the primary context for the composite animal mask, although it is also involved in the graded transition of male initiates within the Poro society.

The basic format is a hood with a human forehead and nose, a muzzle with sharp teeth, and horns projecting at the back. The mask is seen essentially as an antelope head that is given additional features for symbolic and decorative purposes, to add select qualities of the animals or colors to the image.

This particular version because of its simplicity may be a *gbon*, the type used by one of the subethnic groups of blacksmiths in the central region. Its appearance is restricted to the funerals of the senior Poro men, and women and children are banned from the scene. Two such maskers, wearing massive crimson and cream-colored fiber costumes, would perform in abrupt swishing movements before the dead member's house and move away shaking and trembling like the very aged, as a visual remembrance of the generations of ancestors they represent. Later in the village plaza, where the wrapped corpse lies, the crucial rite takes place. After demonstrating its exceptional powers in a whirling dance, the *gbon* straddles the body, walking from its foot to its head three times. This repetition marks the three stages of Poro the deceased had passed through, and the posture of birth-giving defining the movement of the mask over the corpse symbolizes the deceased's rebirth as an ancestral spirit. The rite closes as the officials sing, "He has returned to the country of the ancestors."

Glaze, A. *Art and Death in a Senufo Village,* 1981.

48 — Long face mask 12"
Southeast Guinea, northeast Liberia
Genevieve McMillan — From Verité Gallery, Paris, 1947

Large face masks with close-set eyes and long nose are used among the Konor, northern Mano, and bordering Kpelle people, for duties of social control by men's society officials.

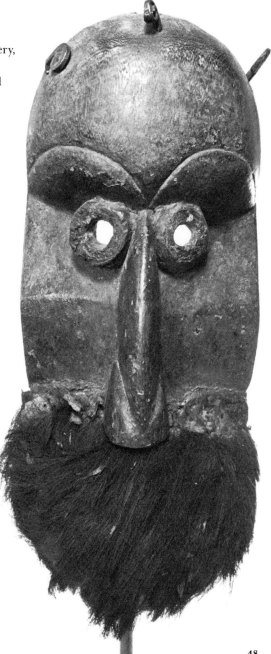

48

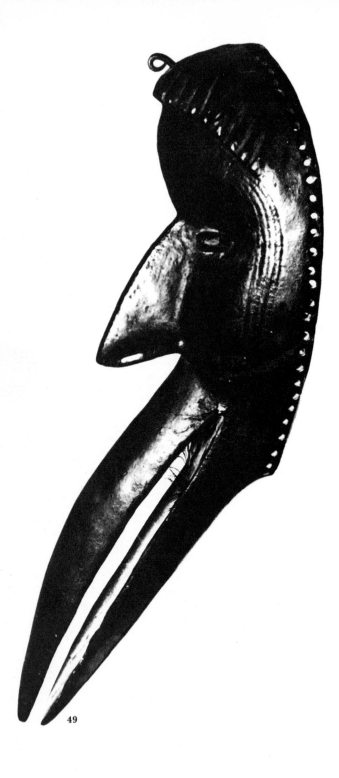

49

49—Face mask with bird beak 16″
Mano-Bassa community, Ziki town
(Zikita?), Liberia
Karob collection—From Boris Mirski,
1974; acquired by George W. Harley by
1937

This mask, described as "the greater horn-
bill" by the medical missionary George
Harley who collected it in Liberia, resem-
bles one he collected in the forties which
carried out the task of collecting debts. For
a fee, the owner of the mask would dress
up in full costume of mask, headcovering,
shoulder cloth, and fiber skirt and go to
the debtor's household. His appearance
would stop all social intercourse and para-
lyze domestic work as the women would
not dare to approach the masked figure.
This pressure was usually sufficient to
obtain payment.

 In this mask, the combination of human
and bird features is adroitly integrated by
the rhythm of the forms in the descending
line of shapes of increasing size for the
forehead, nose, and beak, and the alterna-
tion of rounded and angular shapes in
those features. The scarification lines
around the face suggest an origin in the
northern Mano-Kpelle border area.

Schwab, G. *Tribes of the Liberian Hinterland,*
Peabody Museum Papers 31: Plate 88B,
1947.

**50—Face mask with projecting eyes and
moveable jaw** (iron and glass beads hung
on plaited fiber attachment) 9″
Dan, Liberia
Karob collection—From Pace Gallery,
New York 1975; acquired by George
Harley prior to 1946

Dan masks with sharp planes, pentagonal
shape, cylindrical eyes and beard are asso-
ciated with a masculine behavioral style.
Masks, however, are classed as things, *pa,*
but exhibit male or female character and
forms. Harley described this one as a *gor
glu* (*gor* is the term for a dead leopard). It
does not appear in public, he said, but
remains in the bush where the various reli-
gious specialists (*zo*) join the owner to
drink palm wine together. It superintends
such important events as election of a new
chief, quarrels between clans, and makes
laws to govern the *zo* specialists. Harley

seems to refer to the institution of the holy elder among the eastern Dan in Liberia and the northern Dan of the Ivory Coast, an institution, referred to as Gor, as "mighty as the leopard is in the bush." The central figure of Gor is a very old man who must have lived an upright life. He lives apart from the village, visited by his circle of advisors drawn from the aged heads of families of the village (thus, a Gor society).

The focal point of Gor is the holy house, a little round dwelling house where the holy elder lives as priest to the ancestors' reliquaries. With his great age he stands at the threshold of the realm of death and can serve as mediator between the ancestors and the living. His task is to look after the peace of the village and between villages. He must prevent disputes or when they have broken out, restore the peace. The community supports him and his messenger. If leaders plan a war or great feast, which also brings many people together and endangers the peace, or if they wish to receive travelling troupes or to apply the poison ordeal, they must first consult with the holy elder to gain his approval. He can also issue new rulings to settle prolonged disputes.

However, unlike the most powerful Poro official, the holy elder of the Dan does not supervise initiation nor does he intervene in the ordinary course of activities. The most important requisite of the holy elder is the great mask *gor ge*. Among the Liberian Dan these masks are characterized by projecting cylinder eyes but the other features could be human or animal-like. However, the lower jaw is moveable as an indication of the mask's power to command. This mask is kept in the holy house and makes appearances only at great occasions and at great time intervals. It acquires a crusty surface from various sacrificial substances.

Himmelheber, H. Der Heilige Alte, *Baessler-Archiv* 24:217-247, 1976.
Fischer, E. Masks in a Non-Poro Society: The Dan, *Ethnologische Zeitschrift* 1980, no. 1: 81-88.

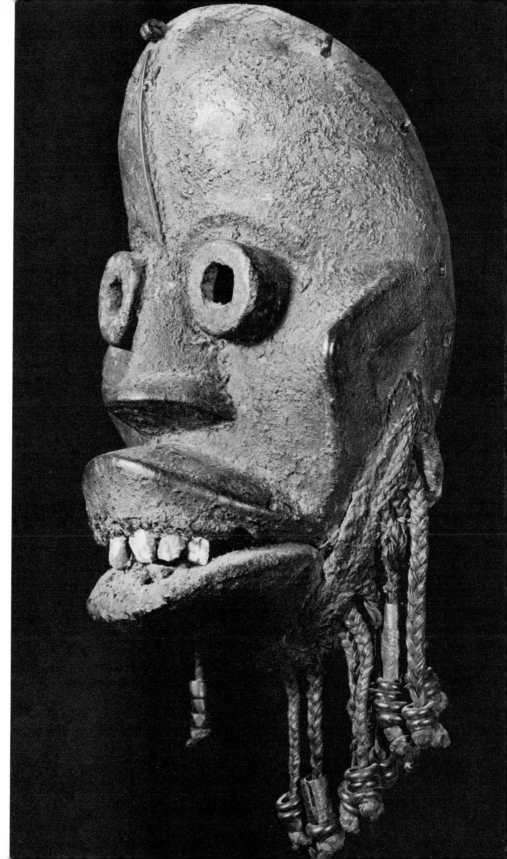

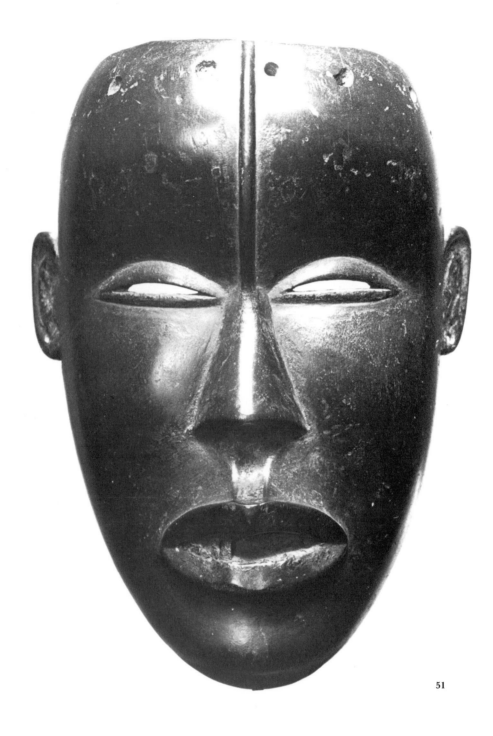

51

51—Fine-featured face mask
Mano, Liberia
Karob collection – From de Monbrison, Paris, 1974; Robin Symes, London; acquired by George Harley prior to 1948

This mask appeared in Harley's 1950 essay (Plate 14d) with the note "no information available," but on his personal copy he marked it "portrait." It is difficult to assign an exact provenance to this example. Not only do several groups in the Liberia-Ivory Coast region produce the same types of mask forms, but also carvers who became widely known for their skill travel about to accept commissions from other ethnic groups of the region. Dan carvers have worked among the neighboring Kpelle and Mano groups, and the influence of their styles also travels to neighboring regions. The fine features of this mask, which could be southern Dan as well as Mano, place it in the class of "female" masks, possibly a singing mask, associated with the circumcision camp, or a graceful character that entertains at festivities.

In regard to function, there is also the life cycle of the mask to consider. In a particular village by good performance over time, this mask could acquire other roles such as village quarter mask or a judge in land disputes. This change would be indicated by the accompanying outfit, which would consist of richer materials and ornaments. The concept of "portrait" in this region differs from the European notion of exact likeness. Too much resemblance is deemed unseemly. The portrait quality is satisfied by minor cues apparent only to local people familiar with the model.

Himmelheber, H. Letter April 10, 1982.
Harley, G. *Masks as Agents of Social Control in Northeast Liberia,* Peabody Museum Papers 32, 2: Plate 14 (d), 1950.
Fischer, E. and H. Himmelheber. *Die Kunst der Dan.* Rietberg Museum, Zurich, 1976.

52—Face mask 8″
Northern Dan, Ivory Coast
Martin and Marion Kilson – From Bernheimer's Antique Art, Cambridge, 1974

A special kind of mask appears in the regions of the Ivory Coast that are open grasslands, outside the densely forested

sections: a mask with pointed oval face and large round eyes, used in boys' competitive races or as fire regulators. In races set over difficult terrain, the challenger wears the mask and tries to tag the unmasked runner on the back. In a more serious vein, a village official dons this type of mask and a bulky costume during the dry season to see that women extinguish their cooking fires before going out to the fields. Spurts of wind could ignite the grass roof of the house and threaten the entire village. The masked official and his assistants punish the offender, and the woman is heavily fined.

Himmelheber, H. Die Läufermasken bei den Savannen-Stämmen der westlichen Elfenbeinküste, *Tribus* 21:77-84, 1972.
Fischer, E. and H. Himmelheber. *Die Kunst der Dan.* Rietberg Museum, Zurich, 1976.

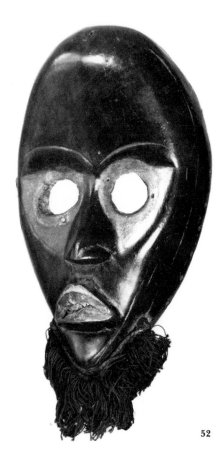

52

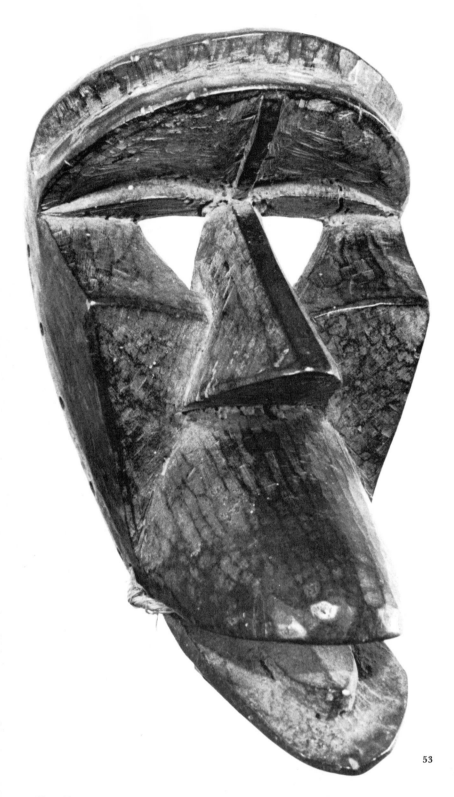

53

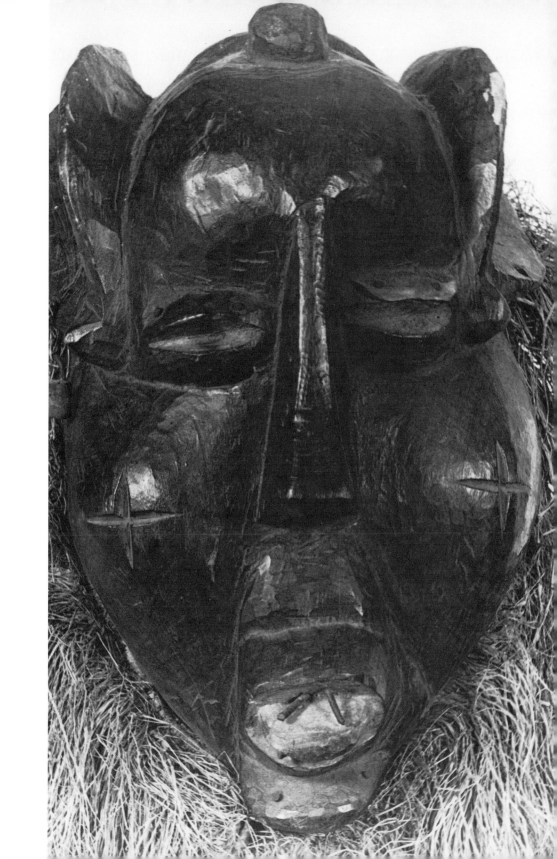

53——**Chimpanzee (*kaogle*) face mask of angular form** 9″
Dan or Wee (Ngere/Kran) of Liberia and Ivory Coast
Karob collection–R. Rasmussen, Paris, 1970

True to form, the figure wearing this chimpanzee mask behaves in an extreme fashion. One of the most striking abstractions of a face, it is admirable as a clever composition of angular forms progressing from the edges of the low forehead, the line of the long pointed nose to the extended mouth. The flanges framing the sides represent the cheekbones. The lower jaw is moveable as the wearer is one of the few masked figures who can speak and be understood by the audience; in use the snout would be lined with red cloth or fur.

The outfit for this kind of mask consists of a wig of cloth rags or cotton yarn, trimmed with feathers or leaves; its costume is a bushy fiber skirt with a cloth over its shoulders. The mask is also generally named after the bundle of hoes or crooked sticks (*kagle*) it carries. These are thrown at the public or used to hook a viewer in order to mock or thrash him. A mask with a distorted or diseased face could fulfill the same function.

The appearance of this figure always occurs in a sudden, surprising way at a public festival where its wild and destructive behavior quickly clears a space for performance. Generally it is abusive and behaves in a shameless fashion with women. It also throws out riddles and puzzles and thrashes any impertinent or conceited persons. It is a striking example of the use of unfettered aggression to stir up excitement, create amusement, and at the same time keep people in their place. Formerly it was a key figure in an association of warrior-like personalities who drank, sang, danced, and fought together during the day but settled down to recount their exploits and feast together in the evenings.

Fischer, E. and H. Himmelheber. *Die Kunst der Dan*. Rietberg Museum, Zurich, 1976.

54——**Face mask with misshapen features**
(also worn horizontally) 19″
Mende, Gola, Vai?, in Sierra Leone and Liberia

Richard Lizdenis, Osterville, Ma.

This deliberately misshapen mask is raised to an art form by its arresting, disturbing quality, rather than a measure of beauty. It intensifies by contrast one's appreciation of the properly formed face, just as the misbehavior of this masked figure should reinforce proper codes of conduct.

Found among the Mende, Gola, and Vai, this kind of masquerader ridicules and insults the spectators in a comic way in between appearances of more serious masked figures or at the funerals of chiefs and rich people. Under the guise of entertainment, the young men who are hidden behind such masks are able to criticize and expose the misconduct of their elders, in a direct manner unthinkable under other circumstances.

The crosses on the cheeks might indicate that this mask comes from the Kpa Mende, where it is a popular form.

Siegmann, W. *Rock of the Ancestors*. Africana Museum, Cuttington University College, Liberia, 1977.
Schultz, Gary. Interview manuscript, February 1, 1964.

55——**Hood crest mask** 21″
Western Grasslands (Babanki-Oku-Babungo area), Cameroon
Stanley H. and Theodora L. Feldberg–From H. Kamer, New York, 1973 (Foumbam)

This special form of mask fits over the head so that the face appears to the viewer as if looking upward; the wearer's face, hidden by a net hood, comes just below the chin of the mask, thus the total masked figure appears taller than normal human stature. This head crest form is typical in the masks of the high plateau region of western Cameroon. In these grasslands there are numerous small "kingdoms" with an uneasy balance of political power between the king with his palace functionaries and the heads of other social groups, especially the men's society (*kwifon*) that has its official headquarters at the capital.

Both the court and the men's society led by the established heads of families are recognized sources of secular and religious authority. The princes and the military also form organizations. Each of these

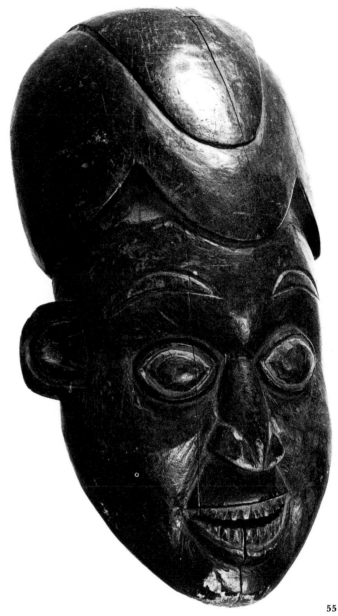

55

groups own masks, some of wood, others of feathers or cloth. Only the masks of the palace groups and the royal family may be decorated with beads or cowrie shells.

Most of the masks that reach our markets were owned collectively by private family groups (lineages) outside the palace organization. At the favor of the palace and the *kwifon*, large and important kin groups could form a mask society made up of 30 to 100 male members, headed by the family chief. Approval from the palace and the *kwifon* was required and it came in the form of grants of secret medicines to add to the masks' powers.

The family mask society would own a fairly standard group of masks which in the western region were carved of wood with human and animal features. The essential pair consists of a male leader mask and his first wife, both depicted as enlarged human faces of similar appearance. Gender is indicated for women by a groomed hairstyle, as in this example, or for men by fancy caps, or a superstructure of special symbols of mystical power such as real human hair or spider, frog, or chameleon images. Male masks were considered dangerous and frightful, feared even by members of the group. Other masks were shaped into heads of elephants, buffalo, or sheep to convey messages about the degrees of spiritual power possessed by the lineage.

Possession of the masks authorized their use in social control over the numerous family members: overseeing community work, leading accused persons to judgment, and carrying out punishments. The masks are also viewed as protection for the family group against enemies and illness. A running mask with human face features, but worn flat on top of the head, fulfilled the same task as the racing mask in the Ivory Coast; it checked the women's hearth fires in the dry season to avoid village conflagrations.

Members of the mask society meet every week in their special house to eat, drink, and practice dancing and music making, in preparation for festive public appearances. The most dramatic occasion is the commemoration, held long after the funeral, of the death of an important person. The performance of certain rites by masked figures, such as the dance of the running mask on the grave, is considered essential to enable the soul to reach the region of the dead. The various social groups bring out their array of masked figures. Costumed in voluminous cloth garments, the masks emerge in processional parades or engage in group dances in a high spirit of competition. The event becomes a display of who possesses the most impressive masked figures and the best dancers.

Koloss, H. *Kamerun Könige Masken Feste.* Linden Museum, Stuttgart, 1977.

Money and Costume

56 — Brass weights for gold dust
Asante, Ghana
Clyde Ferguson – Collected in Ghana, 1959–1973

Fifteen pieces; beginning at lowest row, reading left to right: okra, geometric coil, spoon for gold dust, bean shield, sheath for sword, flower, tool; circular ornament, angular ornament, casing; forest bird, water bird, hammer, air fan for forge.

Karob collection – Acquired in Accra, Kumasi, 1968; birds from Mohammed Kabba, 1971.

Set of birds on stand, antelope, three human figures.
Gold was obtained from panning in the rivers and its use was controlled by the royal court of the Asantehene, head of a political federation in what is now the state of Ghana. These small lost-wax castings in brass were used as weights for measuring the gold dust in everyday commercial transactions, in paying legal fines, and so forth; no other medium of exchange was permitted.

Weights of geometric shape are more numerous (6:1) than those which reproduce in miniature the physical form of items and creatures in the Asante universe. Casting such figurative weights probably began at the end of the 17th century and continued until the end of the 19th century.

The contrast between bush and village is fundamental to Asante ideas about self-

Art and the Community

identification and the moral and physical universe. Many rules of behavior show an avoidance of the pollution that would result from overlapping these basic categories. In the approximately 100,000 or so figurative weights that survive, certain creatures are not represented: beasts which live in the village (domestic animals), scavengers of human food and refuse at the fringe of the village, and a few bush animals which, like domestic animals, are easily killed and even hunted by children. Representations of these creatures are excluded from the system of exchange as they share the qualities which define the danger of money itself: it is an intermediate, marginal substance which equalizes and blurs categories.

Producing weights has been revived in response to the tourist market.

McLeod, M. Goldweights of Asante, *African Arts* 5, 1:8-15, 1972.
McLeod, M. Aspects of Asante Images, in M. Greenhalgh and V. Megaw (eds.), *Art in Society*, pp. 303-316, 1978.

57—Narrow strip woven cloth (*kente*)
122″ x 88″
Asante, Ghana
Kate and Newell Flather—Received as gift from students and teachers of a secondary school, Winneba, Ghana, 1962

Hale, S. Kente Cloth of Ghana, *African Arts* 3, 3:26-29, 1970.
Smith, S. Kente Cloth Motifs, *African Arts* 9, 1:36-39, 1975.

58—Factory cloth sewn in strips
(stamped designs, *adinkra*) 166″ x 180″
Asante, Ghana
Dibby Falconer—Acquired in Ghana, 1960s

Polakoff, C. The Hand-Printed Adinkra Cloth of Ghana, Chapter 5, pp. 83-130, *Into Indigo*, 1980.

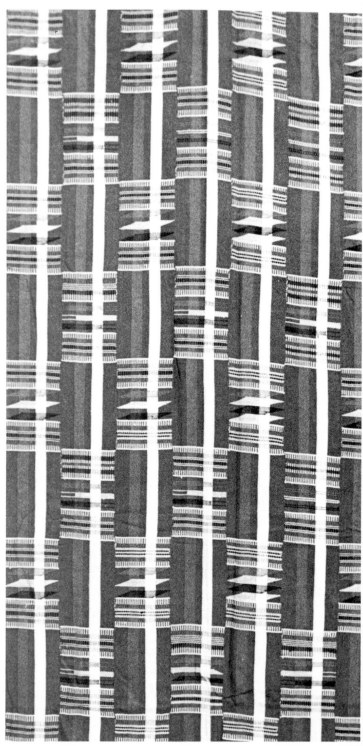

Art and the Community

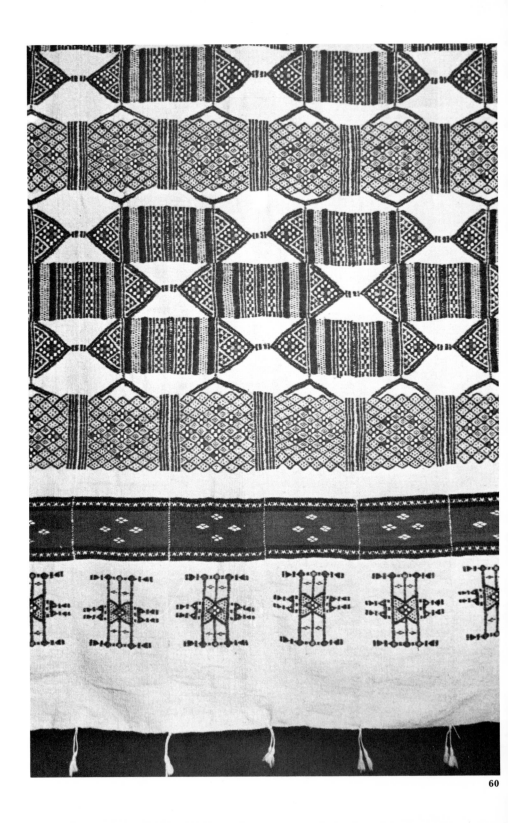

60

59——Blue and white cotton textile
105″ x 74″
Northern Igbo, Nigeria
Barbara and Alan Goldberg—Acquired in Aba market, Igbo area, June, 1981

This kind of patterned cloth is dyed in northern Igboland for use by the Leopard Society of the Cross River area of southeastern Nigeria.

Picton, J. and J. Mack. *African Textiles.* British Museum of Mankind, pp. 150-151, 1979.

60——Wool blanket and wrap (*khasa*)
178″ x 71″

Peul of Mali
Private collection—Acquired in Mali at Bamako market

Imperato, P. Wool Blankets of the Peul of Mali, *African Arts* 6, 3:40-47, 84, 1973.

61——Wool and cotton woven blanket and wrap (*kereka*) 176″ x 67″
Peul of Mali
Private collection—Acquired in Mali at Bamako market

Imperato, P. Kereka Blankets of the Peul, *African Arts* 9, 4:56-59, 92, 1976.

61

62 — Narrow strip cotton cloth 188″ x 56″
Songhai, Niger
John and Susan Garrett—Acquired at
Niamey, 1971

Destined for a big-man wedding that did
not take place, this cloth represents only
half of the original size of the intended
gift.
Similar to contemporary Peul cotton
weaving.

African-American Institute (New York).
Safakke: Textile Art from West Africa, pp. 9–10,
1975.

62

Art and the Individual

One stereotype about African art is its exclusive inspiration by community interests, its unwavering dedication to social cohesion and group harmony. In fact, a considerable amount of African art is created to single out the individual, foster his success, or distinguish him from his fellows. The tension between the individual and the interests of the social group is ever-present. These interests can coincide for members of the founding family of a village, as it is to their advantage for the village as a whole to remain a harmonious unit and prosper; while it is in the interest of an enterprising and less entrenched individual to break away and establish a new settlement where he can enjoy the distinction and privilege accorded to the founder.

Much of the work of religious functionaries, such as native doctors, herbalists, diviners, shrine and cult priests, accommodates the individual client's needs and problems. Of course their efforts and prescriptions are called upon to aid the community in need, and powerful individuals approaching these religious figures may do so on behalf of the community. Nevertheless, this exhibit emphasizes kinds of art that cater to the individual: both the particular cults surrounding the many small figures that are used to personal advantage by individuals in private rites, and the occupational and prestige insignia that set the individual apart from the crowd. Although a certain type of object may be used by many individuals, personal definition is given by its consecration to a limited scope of efficacy, restricted to the owner's specialized issues, problems, and ambitions.

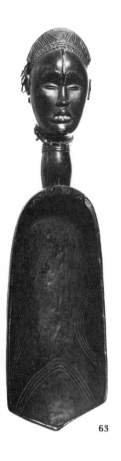

63

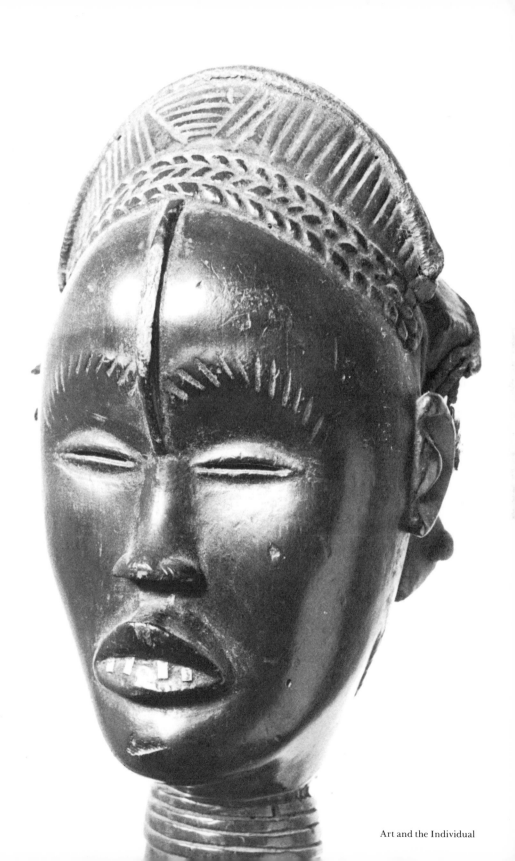

Cult Art for the Individual

63 — Hospitality spoon 26"
Dan, Liberia
Karob collection—Acquired by Alfred
Tulk in Blimi town, Liberia, near border of
Ivory Coast, 1933

No other African people produce such an
elaborate, large, and beautiful ladle form.
It is a requisite of the "most hospitable
woman," the *wunkirle,* of a village or village
quarter, the large size of the scoop sug-
gesting the quantities of rice that she has
generously given away. The feminine head
that forms the handle is a stylized portrait
of ideal Dan beauty: facial contour in a
pointed oval, high forehead, narrow eyes,
thin nose ridge with flaring nostrils, and
full mouth. The hairstyle, indicated by
carved ridges, fine incisions, and plaited
fiber edges, and the scarification designs
on the back both represent real practices
of Dan women and serve as indications of
the special grooming given to persons of
honored status.

To win the right to display and use this
great spoon, a woman must be an indus-
trious and successful cultivator, and she
must gladly and richly entertain often.
Especially she must provide for itinerant
troupes, which teenage youths are
expected to form in order to win renown
as singers and dancers. She prepares meals
for the men who clear the fields and at the
great merit festivals, sponsored by men
seeking status, she must cater to the many
strangers who have travelled to attend the
feast. In order to fulfill these tasks, she
needs a helping spirit who comes to her in
a dream and asks to be manifested in a
great spoon.

The *wunkirle*'s appearance with her
attendants at a feast is a theatrical event.
Coming into the public area, she carries
the spoon swinging it in a special dance
while singing her own *wunkirle* theme
song. She then portions out the rice with
her great scoop into little bowls for the
invited families. At a competitive festival
for all the local *wunkirle,* the scoop is filled
with rice kernels, peanuts, and coins
which she and her female followers throw
into the air, her aides singing to incite her
to ever more generosity. Standing before
all the notables of the area, the judges,

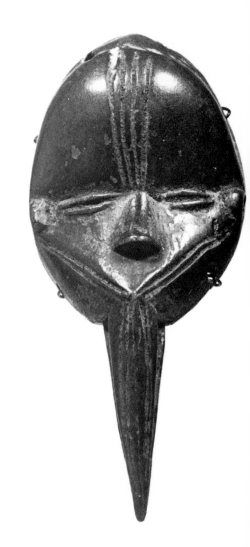

who are outsiders invited there as guests (and therefore impartial), determine which one holds first rank. Men wearing respected masks sing the praises of the winner and her predecessors.

An aging *wunkirle* chooses her successor. But the young woman must first be able to enlist the helping spirit, who appears to her in the most personal way, in a dream asking to be taken care of. Then she feels able to demonstrate her qualities at a merit feast and the spoon is transmitted to her.

Himmelheber, H. Wunkirle, die gastlichste Frau, in C. A. Schmitz (ed.), *Festschrift Alfred Buehler,* pp. 171-181, 1965.
Fischer, E. and H., Himmelheber, *Die Kunst der Dan.* Rietberg Museum, Zurich, 1976.

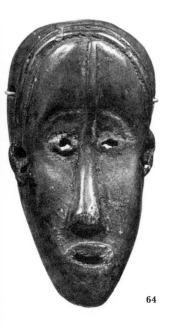

64

64——Personal mask insignia 5″ 3″
Dan or Mano of Liberia
Mr and Mrs Nathaniel C. Burwash—From Boris Mirski, Boston; collected by George Harley in Liberia

Each man of importance in the community had one of the small carved wooden masks called *ma,* just big enought to fit into the palm of his hand. It was kept hidden and revealed only at special rituals. When he travelled, he might show it to indicate his spiritual protector; this custom has given rise to the term "passport" mask. In this region, where masks are used extensively by the adult society, a diviner might advise commissioning a tiny mask for childrens' welfare as well.

Harley, G. *Masks as Agents of Social Control.* Peabody Museum Papers 32, 2, 1950.

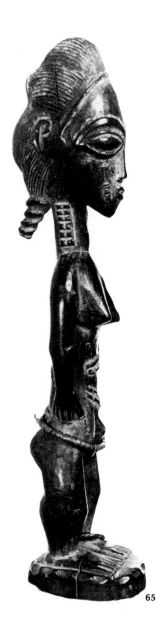

65

65—Standing female figure 9½″
Baule, Ivory Coast
Private collection

66—Seated female figure 16″
Baule, Ivory Coast
Peabody Museum, Harvard University 60-56-50/10442
Photo Credit: Hillel Burger

67—Standing female figure 17¼″
Baule, Ivory Coast
Private collection—From Alain Schoffel, Paris, 1978

The beautifully groomed figures of the Baule have been among the most pleasing to European and American taste. Many are female, and few are ancestor figures. Most of them come into being as part of a private relationship between a person and a spirit, usually developed through dreams. Each person is thought to have a partner of the opposite sex in the spirit world. If one is having difficulties, the diviner may blame one's spirit mate who feels neglected or find that an irascible, mischievous bush spirit has entered the person's life. In either case, if the client is able to afford it, he will commission a carving and placate the spirit by offerings to it. The spirit mate is given personal care by cleaning and rubbing with oil; food offerings are placed in tiny dishes before the figure. In contrast, offerings to a bush spirit are poured onto the statuette. Thus a different surface develops on the two kinds of spirit figures. However, the bush spirit figure is given the hairstyle and scarification markings that characterize the civilized person, in order to help modify its wild nature.

Vogel, S. People of Wood: Baule Figure Sculpture, *College Art Journal* 33, 1:23-25, 1973.

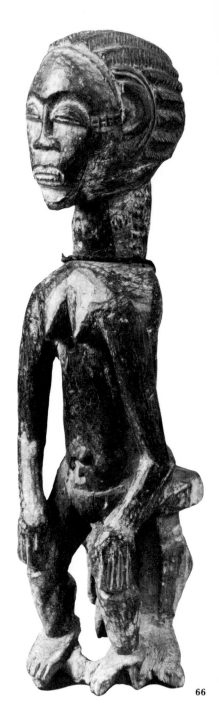

66

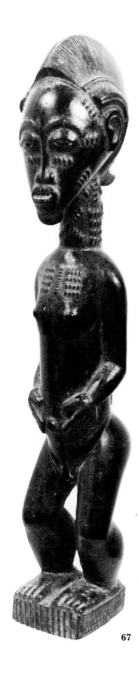

67

68——**Dance wand** (with woman holding a child, Shango cult) 19¼″
Yoruba, southwestern Nigeria
Private collection–From Pace Gallery, New York, 1979

The Yoruba say they have 401 gods as an indication of a multitude. Some are cosmic deities, others culture heroes or locality spirits. On shrines of various deities, one will typically see a carving of a woman holding a bowl or a child or a man on horseback. These figures represent the devotee, usually comissioned as a thank offering to the shrine for a personal favor or service rendered. Details such as the color or material represented by the necklace would link the image to a specific cult.

Given the generality of the shrine images, it may seem strange to link Yoruba cults with the individual. However, the major Yoruba gods and lesser members of their hierarchy are distinguished not only by their specific functions, such as control over storms, use of iron, fertility of the fields, but also differentiated by their dispositions, being characterized broadly as "hot" or "cool," and by individual traits, such as the arrogance and impatience of Ogun, god of iron. The individual Yoruba will generally honor the deities worshipped by his family. However, he is free to join a cult of his choice, and the Yoruba believe that definite personalities are recognizable in members of the various cults. Observers also have noted that the dispositions of worshippers are remarkably like those of their cult gods or else clearly complementary to them.

In addition to the usual woman with child image, a cult may adopt special insignia which indicate its rites and patron spirit specifically. One widely known cult focuses on worship of Shango, the thunder god. When possessed by the god, in violent frenzied states, devotees dance with this kind of wand, enriched by a female figure with child. Above her head rises a symmetrical form depicting two stone celts that are signs of Shango's cosmic powers.

This particular figured dance wand is a masterpiece of Yoruba style, which can be localized to the Igbomina Yoruba, Oro area. Each part of the body is clearly defined and separated. The facial features with characteristic open, ringed eyes, pro-

ject forward in exaggerated dimensions. This facial thrust, the upright breasts, and slightly bent arms combine to give an impression of alert vitality.

The Yoruba conceive of the role of the mother as just, restrained yet generous, and they explain this kind of image on the dance wand as having a calming, "cooling" effect upon the hot impulsive nature of the god. Thus the mother image projects a model of the state the deity should reach in order to fulfill the desires of the devotee.

Morton-Williams, P. An Outline of the Cosmology and Cult Organization of the Oyo Yoruba, *Africa* 34:243-261, 1964.
Fagg, W. and J. Pemberton. *Yoruba Sculpture of West Africa.* Pace Gallery, 1982.
Odugbesan, O. Femininity in Yoruba Religious Art, in M. Douglas and P. Kaberry (eds.), *Man in Africa,* pp. 199-211, 1969.
Thompson, R. *Black Gods and Kings.* Museum of Cultural History, Los Angeles, 1971.

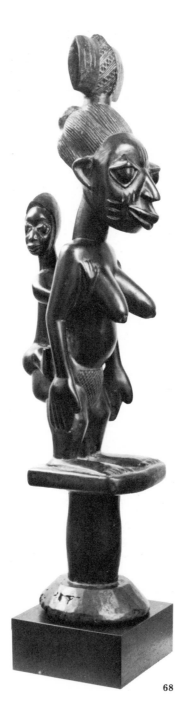

68

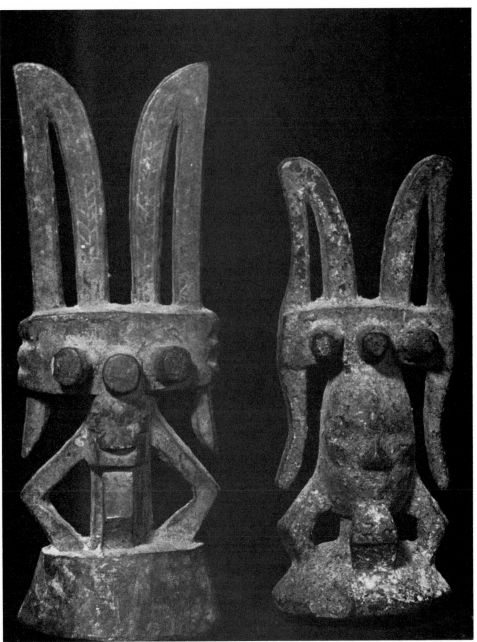

69——Two abstract cult figures (*ikenga*)
12½" 9¾"
Igbo of southeastern Nigeria, Otago
village area
Stanley H. and Theodora L. Feldberg—
From Chaim Gross, 1972
Boris Senior—From Egon Gunther,
Johannesburg, 1964

The cult of the right hand in southeastern
Nigeria is one of the best examples of the
spiritual focus on the individual and his
aspirations. A person with prospects of
success will establish a shrine in order to
honor his right hand, a symbol of his
power to accomplish his aims, "to make his
words come true." These are called *ikenga*,
meaning "place of strength." The *ikenga*
figure is dedicated to a man's ability to
make his way in the world, and the cult
reflects the Igbo's aggressive interest in
achievement.

A typical time for a male to acquire an
ikenga is when he moves into his own house
in his father's compound or sets out to
improve his fortunes. *Ikenga* are readily
available in the market and gain in
strength when consecrated at home with
ritual sacrifice. The essential attributes are
two horns protruding from a base, the
horns suggesting strength and vigor. As a
man succeeds and consolidates his power
through title holding, he may commission
more elaborate *ikenga* until he possesses a
carving of a man seated on a stool with a
sword in his right hand and the head of a
defeated enemy in his left. Thus the elabo-
ration of form is directly related to the
rank of the owner. The *ikenga*'s efficacy
does not extend beyond the owner's life or
person. No one else can use it, and it is
destroyed or buried upon the owner's
death.

Vogel, S. *Gods of Fortune: The Cult of the
Hand in Nigeria.* Museum of Primitive Art,
New York, 1974.
Boston, J. *Ikenga.* Federal Dept. of Antiq-
uities, Lagos, and Ethnographica, Lon-
don, 1977.

69

Small Figure Sculpture

70—**Female figure** (seated on a stool)
10″

Senufo, Ivory Coast
Daniel and Barbara McGaman

71—**Standing male figure** 8½″
Senufo, Ivory Coast
Bardar collection—From J. Klejmann,
New York, 1961

In contrast to masks which make dramatic
appearances before crowds in the public
arena, small figures like these are part of
the private session an individual has with a
diviner. Nearly all small-scale woodcarv-
ings belong to the category of Sando divi-
nation sculpture, called "little spirit," or
"bush spirit." These may represent an ideal
social unit of man and wife, commemora-
tive images of recently deceased elders,
twins, or the idealized Poro and women's
society (Sandogo) initiate, and so forth.
Their primary role is as mouthpieces or
messengers of beings in the supernatural
world through which the diviner commu-
nicates with the spirit world. The Sando
diviners are women. The figures are
placed on a mat before the diviner: these
must include the male and female pair,
plus as many others as she wants. An indi-
vidual figure may serve as a special oracle
for a particular client. Only a successful
diviner can afford the better sculptors.

Glaze, A. *Art and Death in a Senufo Village.*
1981.

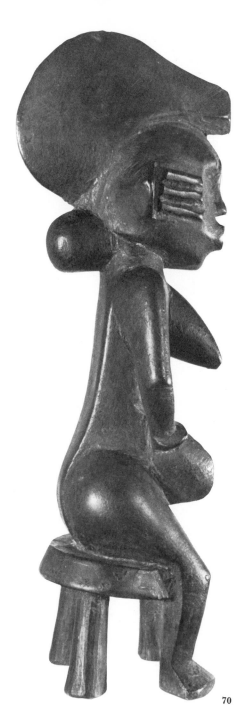

70

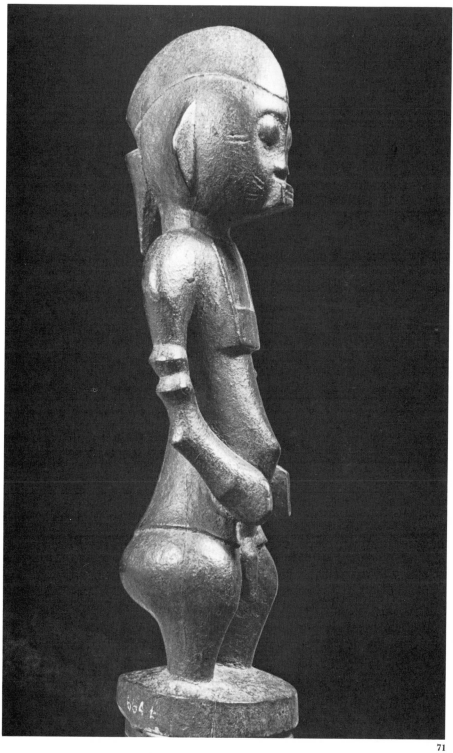

Art and the Individual

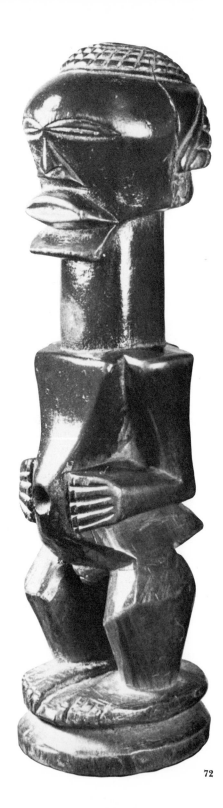

72

72——**Male standing figure** 8½"
Songye, central Zaire
Private collection

The greatest importance of ancestral spirits lies in the belief in their powers to bring children into the world. Among the Songye, supplication for that purpose involves the use of two types of human figures: the first is an individually commissioned and owned figure, the second a much larger figure owned in common by all the people of a community.

The individually owned figures are small, ranging up to 12". Each is given a personal name and provided with the gender of the child desired. The man desiring a child either carves the figure himself or commissions one from a specialist. Once carved the finished figure is taken to a native medicine doctor who combines special ingredients and puts the mixture in holes made in the figure, usually at the top of the head and at the navel. In former times the most common receptacle was the tip of a small antelope horn stuck on top of the figure's head, but today this is omitted. At home the supplicant makes sacrifices and small offerings to the figure from time to time. The spirits appealed to are pleased and intercede with the Creator to approve.

Merriam, A. *An African World,* 1974.

73——**Standing male figure with added substances**
Teke, Republic of Congo
Bardar collection—From Alain Schoffel, Paris, 1978

This figure provides the image of the classic "fetish," that is, an object put together of various materials. Earlier men and women could own several small wooden figures, usually male or without gender, each dedicated to a specific purpose of its owner, such as warding off illness or protection while hunting or travelling. Large figures for the same purposes belonged to a medicine man serving the community or chief.

The added material gave the figure its effectiveness. The local medicine man would cover the owner's figure with a secret combination of earths, leaves, and other organic materials, which in combination with verbal formula consecrated the spirit to the owner's purpose.

Figures of this shape, called *iteo,* could incarnate a spirit of good fortune or an ancestor. The hair dressed in a crest and the scarification lines of the face reflect actual practices of the Teke, and formerly variations in style distinguished subethnic groups.

If a man's undertakings fail, he assumes witchcraft has weakened his fetish; the native doctor tries to restore it by playing music or exploding a bit of gunpowder. If bad luck continues, the figure is beaten to drive out the harmful forces that possess it. Upon the death of the owner, the fetish is buried with him.

Hottot, R. Teke Fetishes, *Journal, Royal Anthropological Institute* 85:25-36, 1956.
Lehuard, R. *Statuaire du Stanley-Pool.* Villiers-le-Bel, France, 1972.

74——**Female figure holding a bowl** 8¼"
Lulua, western Zaire
Karob collection—From Donald Morris, Detroit, 1978

In producing small figures of a man with a weapon or a woman with child or bowl, the Lulua have created an unmistakable style which treats part of the body as points projecting from a central core, the surfaces notable also for abundant keloids, which are raised scarification designs. As often in central Africa, the appearance of the carving is affected by use; the figure exhibits the remains of rubbed-on colored powders. Little is known about these figures except that one is carved for the pregnant woman to assure safe birth and also for the reincarnation of dead infants. The bowl or on some figures the cupped left hand is to receive white clay powder as an offering to the spirit.

Fagg, W. *African Majesty.* Art Gallery, Toronto, 1981.
Himmelheber, H. *Negerkunst und Negerkünstler,* 1960.

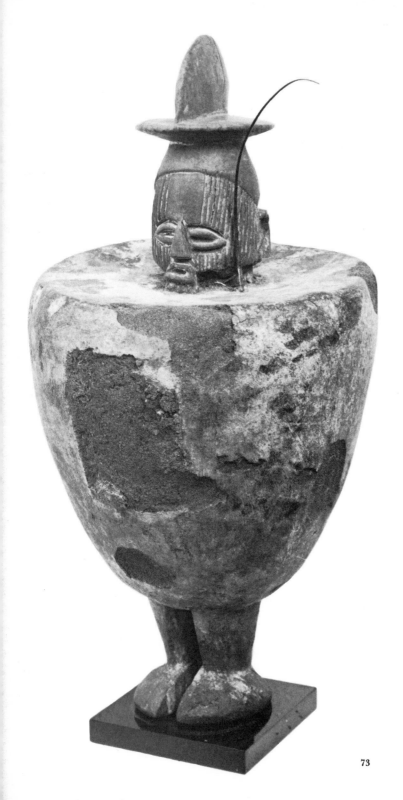

73

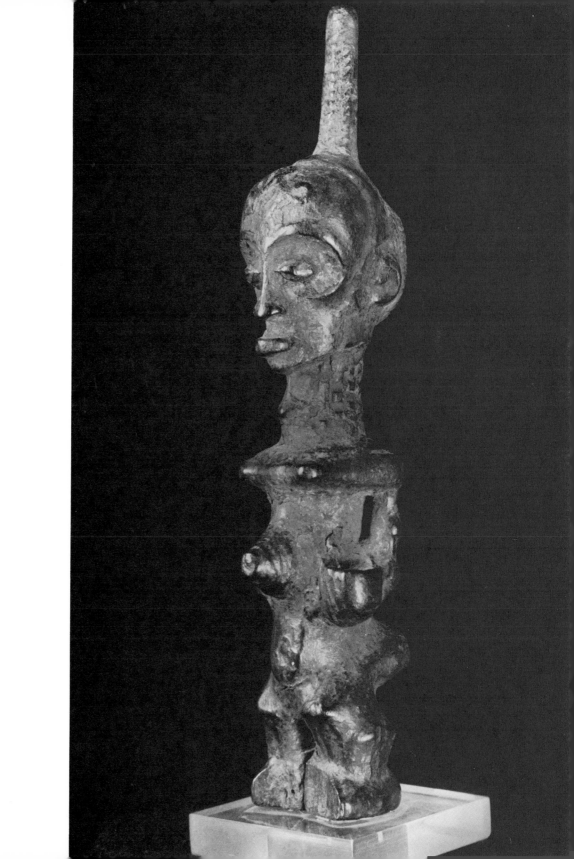

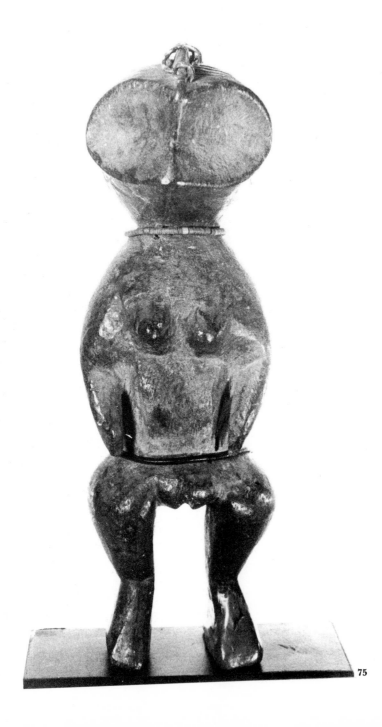

75

75—Female figure 11″
Northern Zaire
Adele and Boris Magasanik

The degree of distortion of the human figure and the interplay of round shapes give this figure visual interest. Certain shapes, such as the concave facial planes and the sharp indentations of the body sections, resemble small figures from ethnic groups of the Ubangi-Uele River region of northern Zaire, such as the Ngbaka, Mbanja, or Zande, but it is difficult to assign a specific place of origin. In this region small figures, created in response to dreams, are used by medicine men and diviners in communicating with the spirit world on behalf of a client.

Burssens, H. Sculptuur in Ngbandi stijl, *Kongo-Overzee* 24: 1-52, Plates, 1958.
Burssens, H. Letter May 12, 1982.

76—Small standing figure 8″
Fang, Rio Muni
Private collection—Obtained at end of
International Exposition of Arts and
Techniques of Spanish Guinea (now
Rio Muni), Seville, 1929

This very fine and rare small Fang figure,
because of its size, may have been used in a
personal context. The right leg of this fig-
ure has been replaced.

Cf. Veiga de Oliveira, E. *Peoples and
Cultures Overseas.* Museum of Ethnology,
Lisbon, 1972.

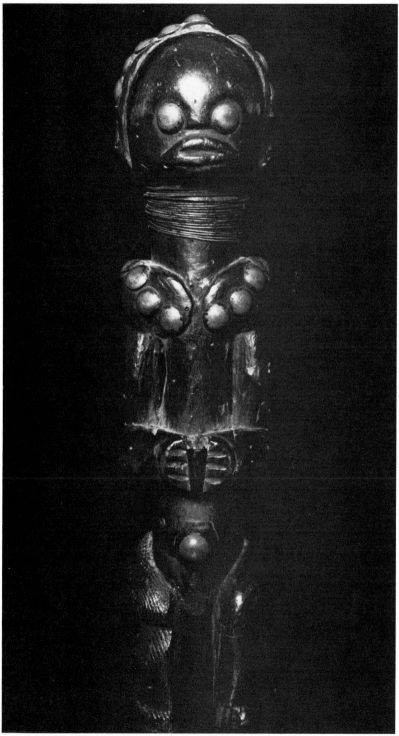

Signs of One's Calling

Many kinds of objects, particularly staffs, serve the individual as insignia of occupation. Holding staffs instead of weapons is an immediate indication of peaceful intent. Elaboration of imagery on the staff yields further information about the owner. Chiefs' political control is a power over people, and often chiefly staffs include small human figures at the top which signal their position under the chief's hand. The paddle-form in central Zaire refers to the original ancestors who paddled one of the many tributaries of the great Zaire River to settle at their present location.

The diviner's staff includes images of animals particularly linked with the spirit world because of their unusual features, such as the chameleon who swiftly changes color and walks so oddly, or replicas of weapons, symbols of the diviner's struggle against harmful forces. A Yoruba smith having achieved a title may acquire a complex staff of prestigious metal. A tunic for a hunter indicates the dangerous character of his profession by the array of attachments, both protective and aggressive. These individuals stand out from the rest of the population, most of whom are farmers.

77

77—Chief's staff in the shape of a paddle
54½"
Luba-Hemba, eastern Zaire
Bardar collection—From J. Klejmann,
New York, 1962
Cf. Vansina, J. Kuba Art and its Cultural
Context, *African Forum* 3/4:13-27, 1968.

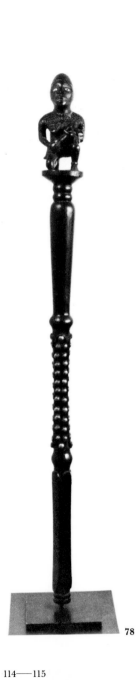

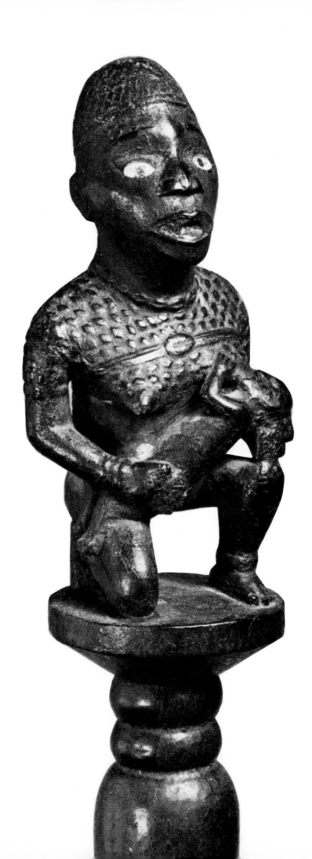

78

78—Staff, mother and child finial 28″
BaKongo (Yombe), Congo
Karob collection—From Pace Gallery, New
York, 1976; Lance Entwistle

79—Chief's staff (human head finial) 34″
Luba, southern Zaire
Karob collection—From Lance Entwistle,
London, 1978 (said to have come from
Portugal)

79

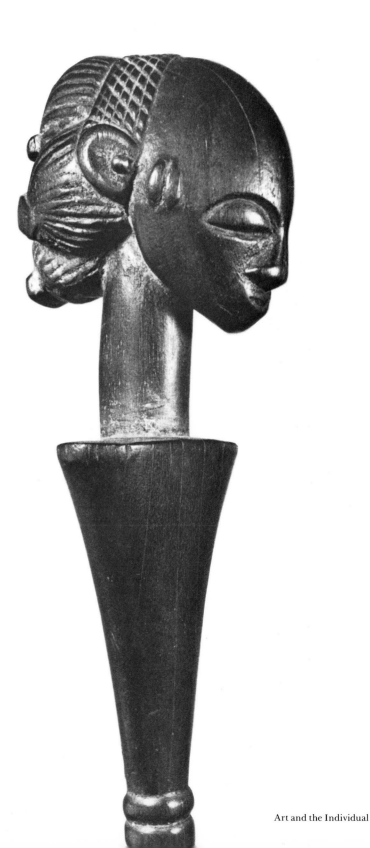

Art and the Individual

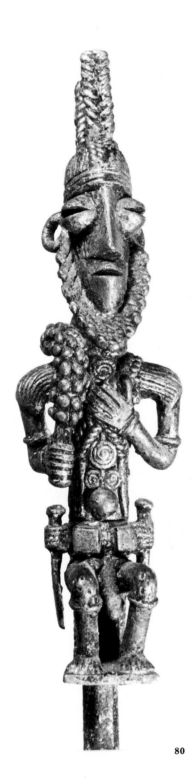

80

80 — **Brass finial** (seated costumed human figure for staff of titled smith) 11″
Yoruba, southwestern Nigeria
John and Virginia Demos — Acquired in Ibadan, Nigeria, 1963

Thompson, R. *Black Gods and Kings.* Museum of Cultural History, Los Angeles, 1971.

81 — **Medicine man's iron staff** (with bells chameleons, surmounted by bird of the night and weapons) 44″
Edo of Benin City region, southern Nigeria
John and Virginia Demos — Acquired at Sotheby's, New York, 1970

Ben-Amos, P. Men and Animals in Benin Art, *Man* 11: 243-252, 1976.

82 — **Hunter's tunic and cap** (with attachments) 33″
Mande (Maninka, Bamana), Mali
Genevieve McMillan

McNaughton, P. The Shirts Mande Hunters Wear, *African Arts* 15, 3:54-58, 91, 1982.

81

Designs on Prestige

The use of artistic objects to *create* prestige is repeatedly encountered in black African societies. Most of these art forms are associated directly with the person, such as richly worked costume and elaborate jewelry worn to command admiration or esteem. One kind of object important in a number of African societies is a piece of personal furniture, a stool or chair, that by its nature raises the person above others, normally seated on the ground. The three types shown here are elite versions and give some indication of the variety of interesting seating forms.

Tools and weapons, also close to the body, may be elaborated to enhance one's renown. Freestanding display items possessed by virtue of the owners' high position include human and animal figures carved in wood or cast in brass. In some localities humor plays a considerable part in fashioning such objects, especially incongruities of size or shape, such as a solid trumpet in wood. However, the human figures owned by wealthy men, like the Dan brass image of a woman, present idealized social persons associated with the owner's household.

83——**Female figure** (brass) 8″
Dan, Liberia
Karob collection—Acquired by Alfred
Tulk from George Dunbar, District
Commissioner, Sanequelle, Liberia,
December 1931 (Dunbar said it was
collected in payment of taxes.)

Fischer, E. and H. Himmelheber. *Die Kunst
der Dan*. Rietberg Museum, Zurich, 1977.

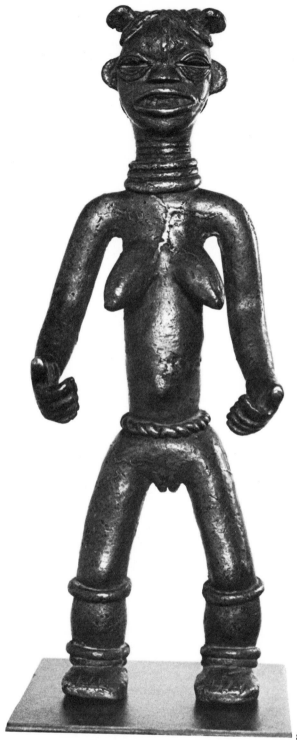

83

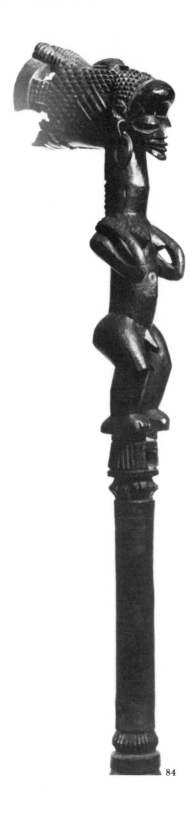

84—Adze handle (human figure finial)
16″
Chokwe, in Angola and southwest Zaire
Karob collection–From Gaston de
Havenon, New York, 1979; Pace Gallery

The blade would be inserted at an acute
angle in the deep cut in the forehead. This
is a delicate and elaborate version of the
adze, a tool used by a carver for chipping
wood. In this form it is an honorific sign
worn over the shoulder by a sculptor or
important person.

Bastin, M-L. *Art Décoratif Tschokwe.* 1961.

84

85—**Three-legged stool** (antelope head)
26″
Lobi, Upper Volta, Ghana, Ivory Coast
Daniel Bell

Meyer, Piet. *The Lobi.* Catalogue, Rietberg
Museum, Zurich, 1980.

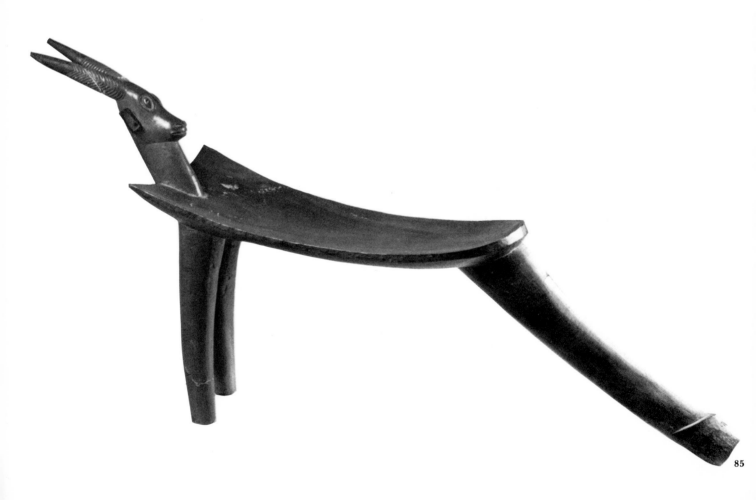

85

86—**Chair** (inspired by European models, trimmed with aluminum) 22″
Loma, Liberia
Richard Lizdenis, Osterville, Ma.

Cf. Himmelheber, H. Die Grossvatter Stühlchen der Guere, *Baessler-Archiv* 13:539-545, 1965

87——**Elite stool** (with circular design and openwork center post) 12″
Asante, Ghana
Lorna Marshall—From Boris Mirski, Boston, 1959

Sarpong, P. *The Sacred Stools of the Akan.* Kumasi, 1971.

87

Endgame

The Powerful Outside:
Motifs Adopted into Art Forms from Foreign People Viewed as Powerful.

88—Costumed man on horseback 22½″
Ewe? Togo
Genevieve McMillan

In the 1920s and 1930s the influence of European colonial administration affected the economies and power of local authorities to a considerable degree. Carvers appropriated the image of the powerful colonial officers into their work for local use and in some cases for sale to colonials.

This particular piece shows a typical white colonial officer with pith helmet, shirt, and trousers. However, he is wearing brass leg rings and his arm is raised in the pose of holding a spear (now lost). His horse, a sign of high status, stands on a base shaped like an Islamic board. This mixture of local and foreign features suggests that the figure was to be incorporated into a local ritual usage, perhaps as a shrine figure.

The varicolored surfaces and vaguely rounded features suggest an origin among the Ewe in the state of Togo. The carving of the horse's body shows the neck and tail as curving forms in space, an unusual stylistic feature for an African carver.

Cf. Walker, R. *The Stranger Among Us.* National Museum of African Art/Smithsonian Institution, 1982.
Walker, R. Letter May 13, 1982.

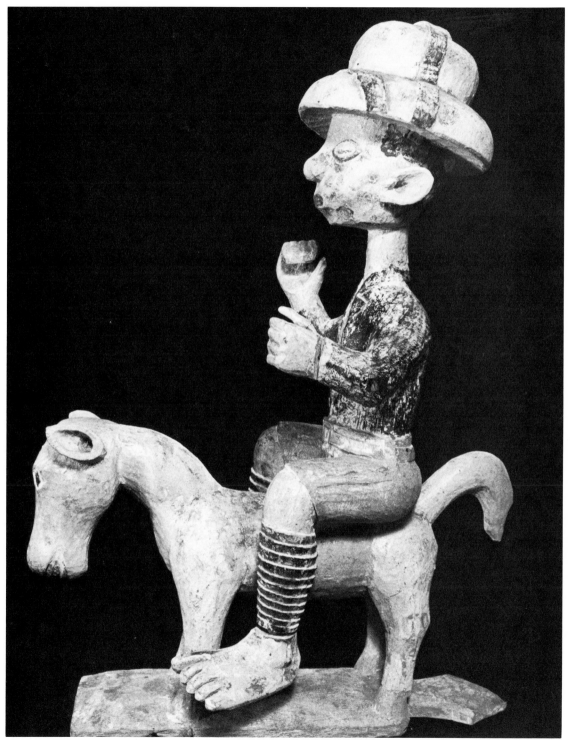

Endgame

89—Two beaded leather aprons 22″ 28″
Ndebele, South Africa
Suzanne and Norman Priebatsch—
Acquired in northern Transvaal, South
Africa, 1977

These aprons belong to the ceremonial
dress of Ndebele married women. The one
with five lappets along the bottom edge
(*jocolo*) is the more formal of the two.

A woman's first beaded apron is gener-
ally made by her mother-in-law after sev-
eral months of marriage; after that she
may make others for herself. The beads
come to South Africa through trade chan-
nels from Czechoslovakia. Such beads have
been plentiful in South Africa since at
least the early part of the 19th century.

We consider these types of aprons to be
traditional, that is, characteristic of the
late 19th and early 20th century, although
both may have been made within the last
50 years. The central design on the *jocolo*
and the small dark-colored vertical design
above the fringe of the other apron repre-
sent airplanes. The basic structure of the
designs on the aprons is symmetrical but
the placement of the colors is random: this
creates a lively effect. The Ndebele wom-
en's interest and skill in colorful abstract
patterning is brilliantly demonstrated in
the painting of their houses and village
walls.

Tyrrell, B. *Tribal Peoples of Southern Africa.*
Cape Town, 1976.

Endgame

90—**Two beaded dance wands** 27″ 45½″
Ndebele, South Africa
Suzanne and Norman Priebatsch—
Acquired in Ndebele village in northern
Transvaal, 1977

Here one sees the forceful attraction of
things from the powerful outside: one a
small model of a telegraph pole, the other
an actual tennis racket with the ball indi-
cated by an attached hanging mirror. Both
these objects are vivid signs of power taken
from the European way of life. The tennis
racket was picked up as a discarded item.
The beads originating from Czechoslova-
kia are purchased from traders. Neverthe-
less, the wands are used by women in cus-
tomary processional dances.

In recent times the Ndebele create
beaded ornaments for sale to tourists.

Priebatsch, S. and N. Knight, Traditional
Ndebele Beadwork, *African Arts* 11,
2:24-25, 1978.

90

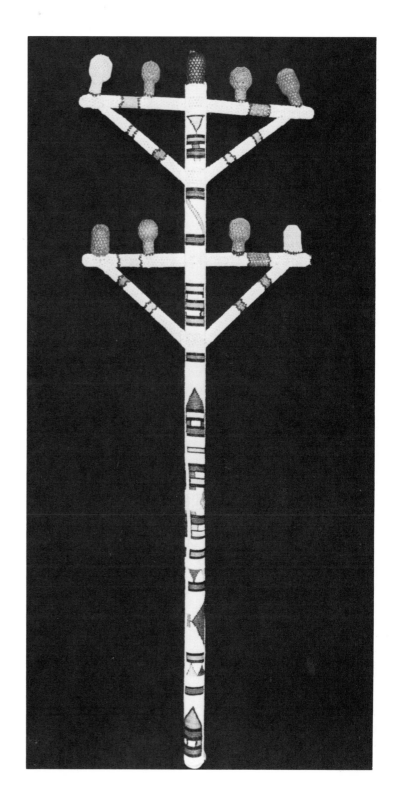

Endgame

Design for Beauty's Sake

Many African carvings appeal to us for their beauty of form, regardless of their meaning or function. Beauty of form plays some part of their design for living as it does for our own.

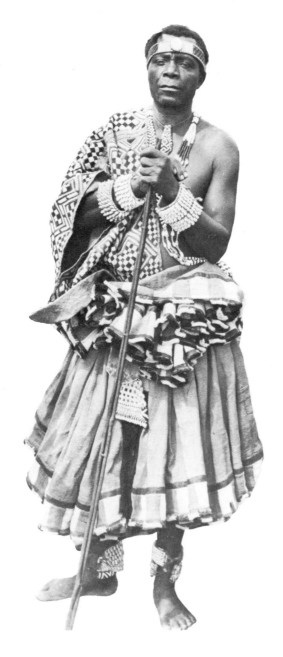

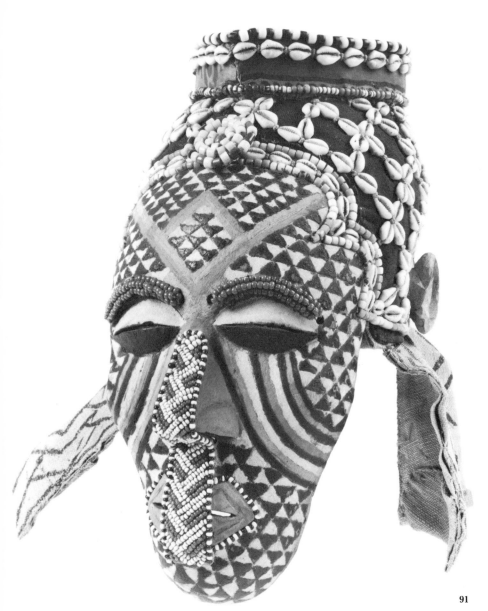

91—Decorated mask 14″
Kuba, central Zaire
Peabody Museum, Harvard University
17-41-50/B1906—Collected between 1890
and 1910 *(Front Cover)*
Photo Credit: Hillel Burger

91

Endgame

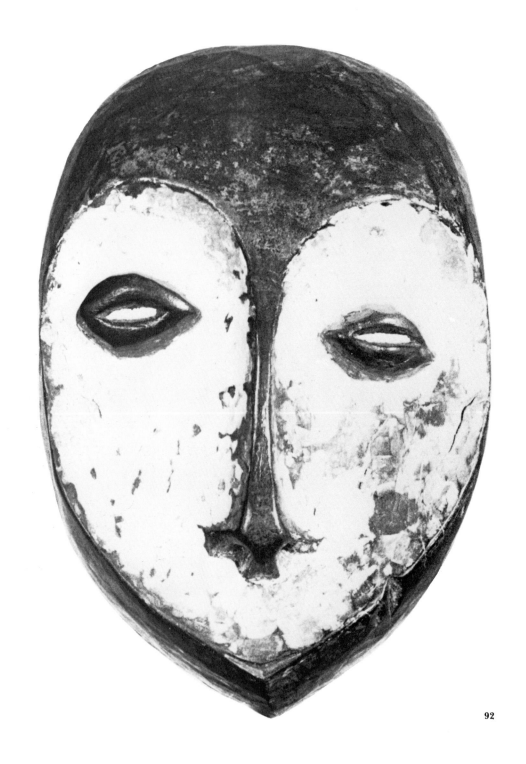

92

93

Endgame

92—Plain mask 9″
Lega, eastern Zaire
Private collection—From D. M. Collins,
London, 1970; McAlpin collection

93—Black polished pot 10″
Zulu, South Africa
Prof. and Mrs. Ithiel deSola Pool—
Acquired at Durban, a South African port
by Mrs. David deSola Pool, 1971

94—Delicate neckrest 6¼″
Shona, Zimbabwe
Bardar collection—From Carlebach,
New York, 1962

95—Blackened wood jar on 3 legs
(with lid) 19″
Zulu, South Africa
Dr. and Mrs. L. Lee Hasenbush—From
Amsterdam antique dealer in early 1960s,
with note from missionary

96—Two tiny brass figurines 2″
Archeological, Mali
Hans Guggenheim—Obtained in Mali

97—Head of donkey (used as puppet)
Bamana, Mali
Boris Senior—From Egon Gunther,
Johannesburg, 1962

98—Slit gong 16″ x 32″
Mangbetu complex, northeast Zaire
Bardar collection—From Bernheimer's
Antique Art, Cambridge, 1968

94

95

96

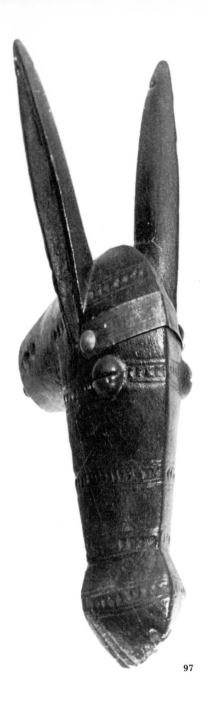

97

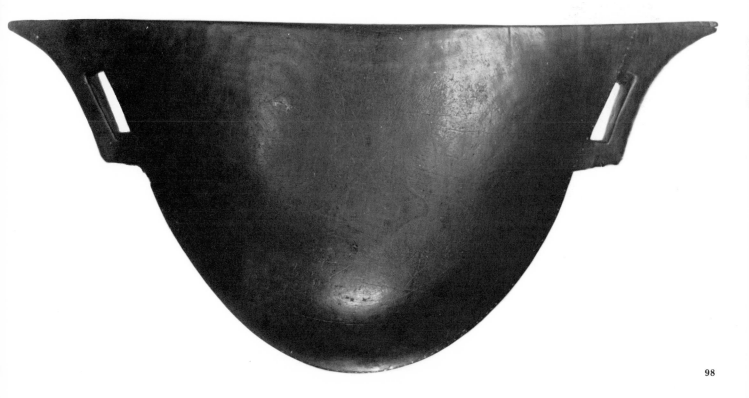

Endgame

99——Mortar on human figure base 12″
Mbala, western Zaire
Private collection—From Merton Simpson,
New York, 1978; Belgian private collection
(Brisson)

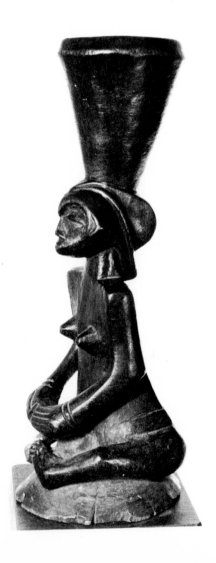
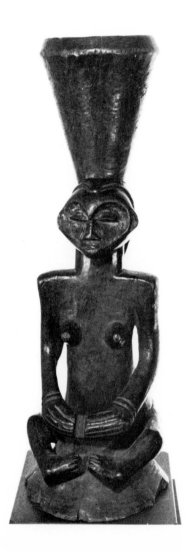
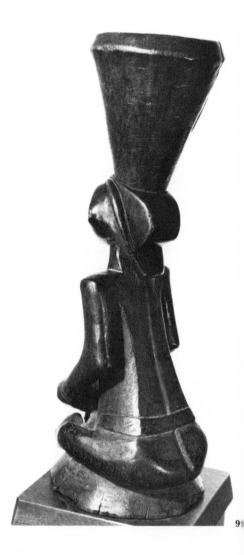

9